Fujiyoshi Brother's COLORING BOOK

Paradise of Animals

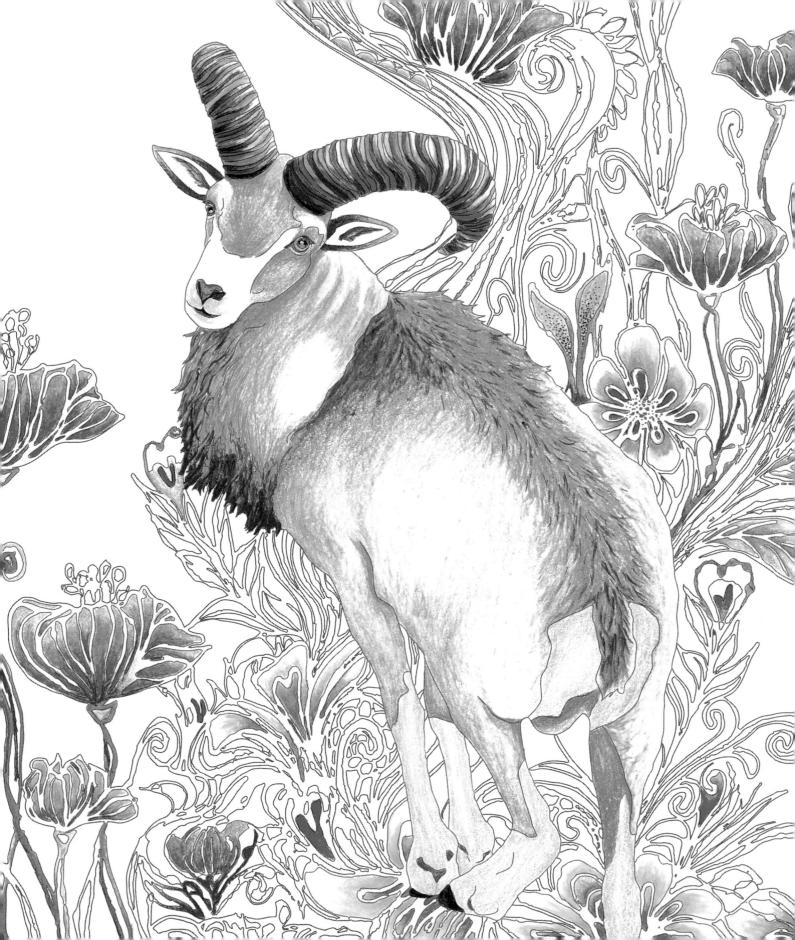

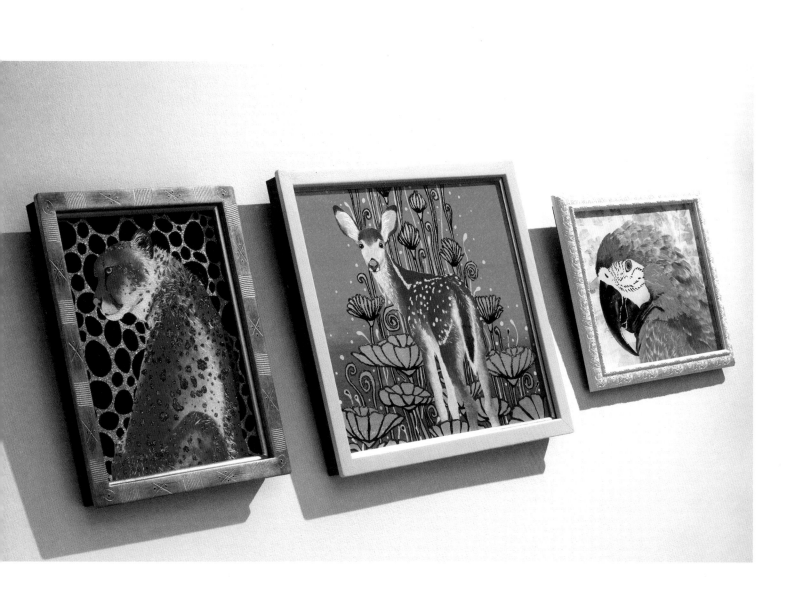

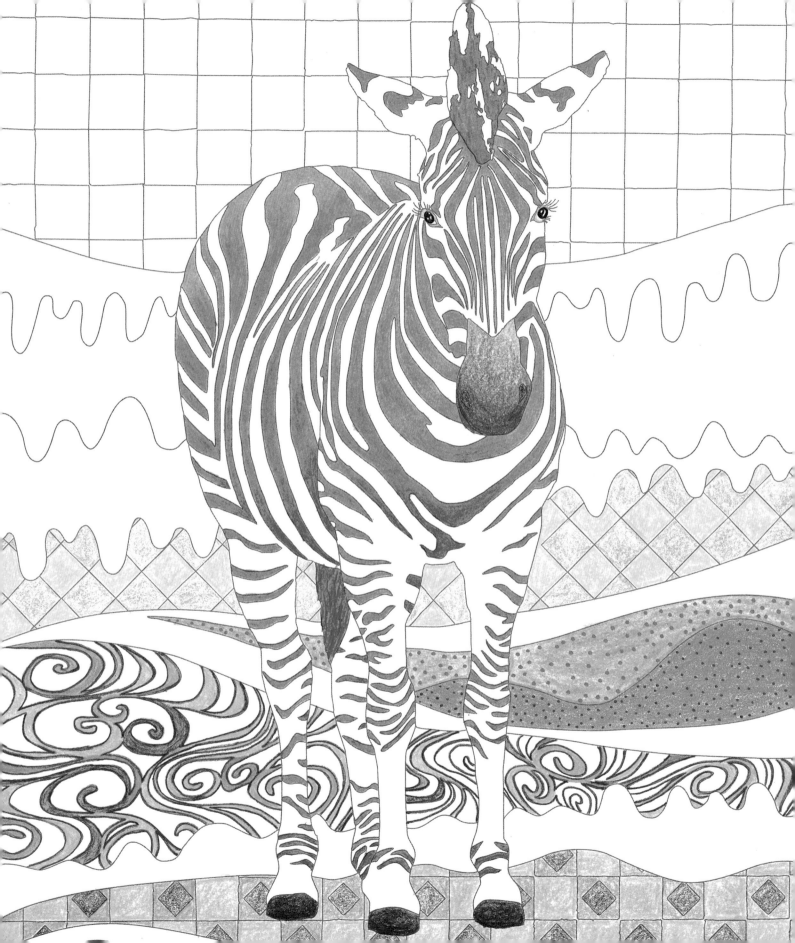

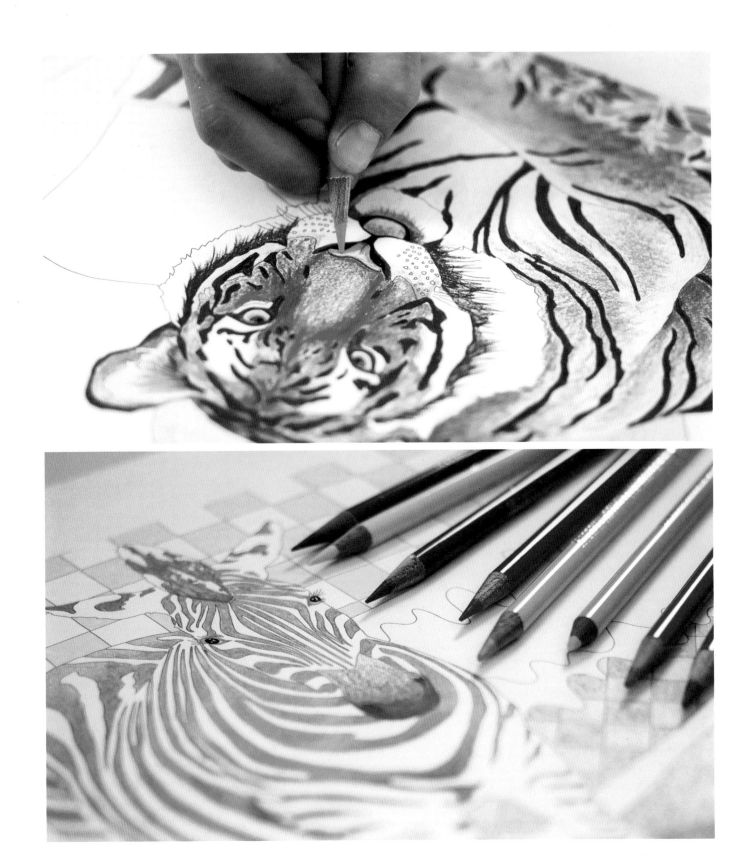

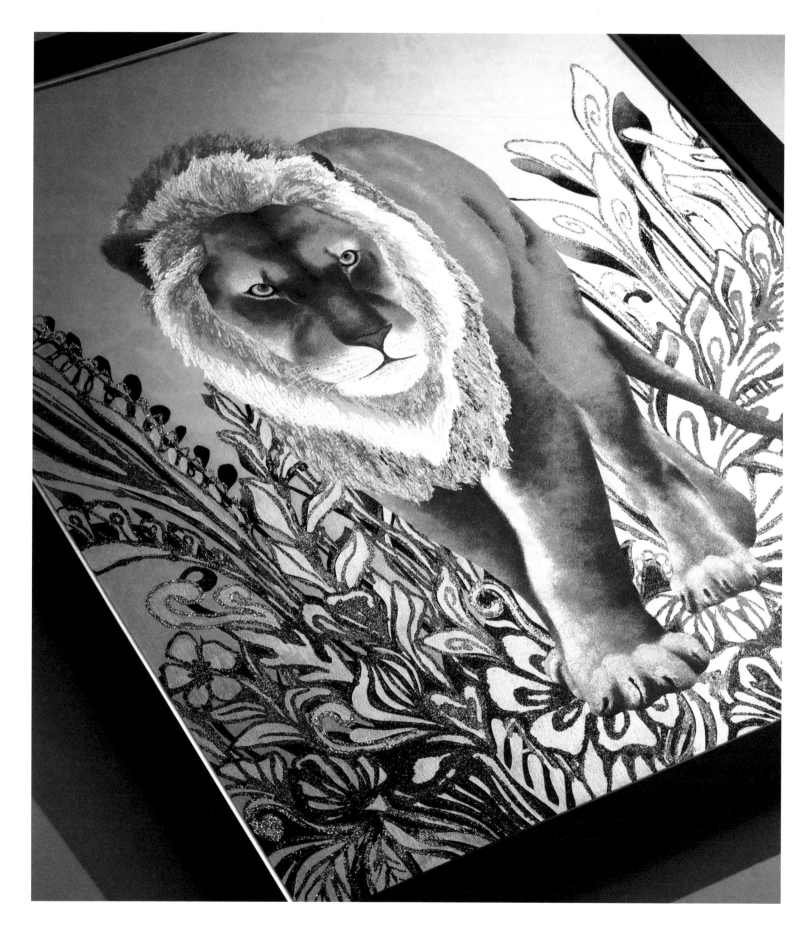

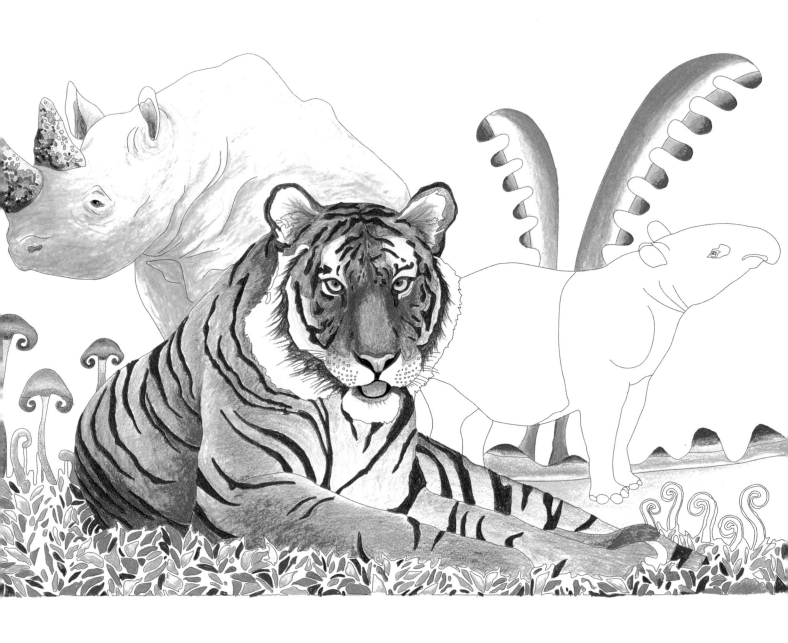

Peaceland Autumn

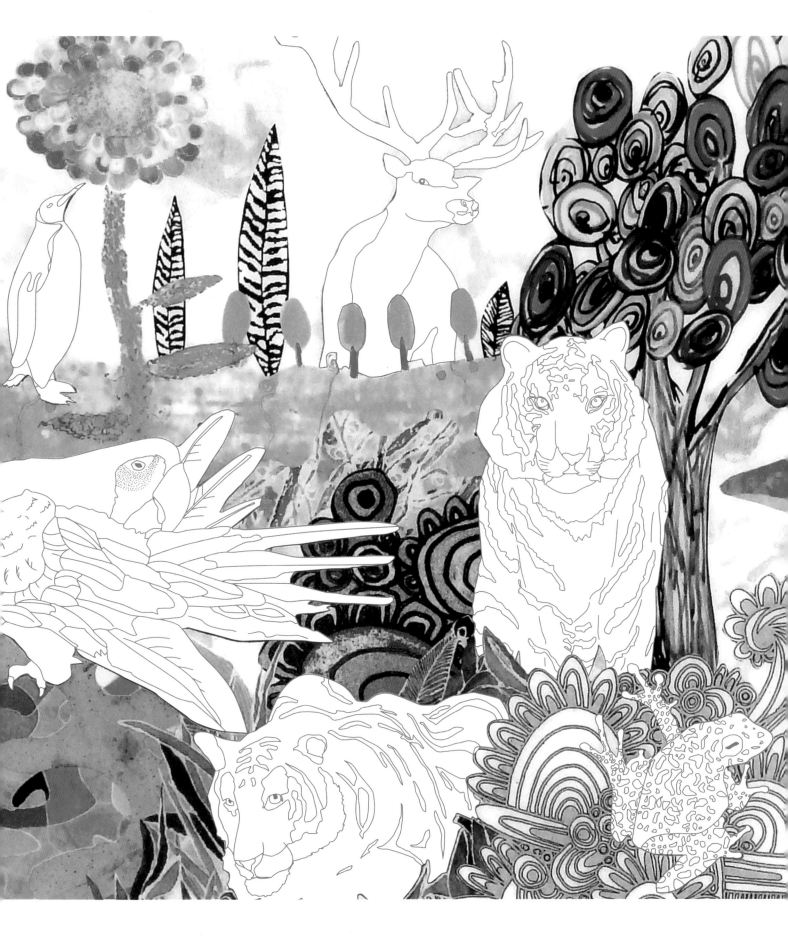

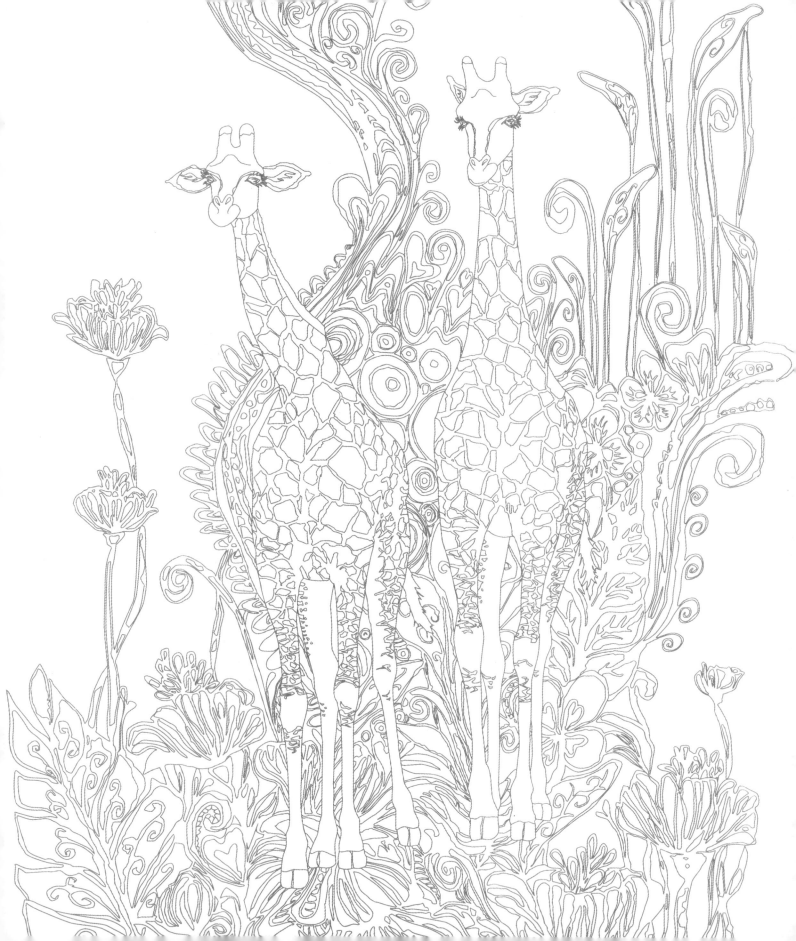

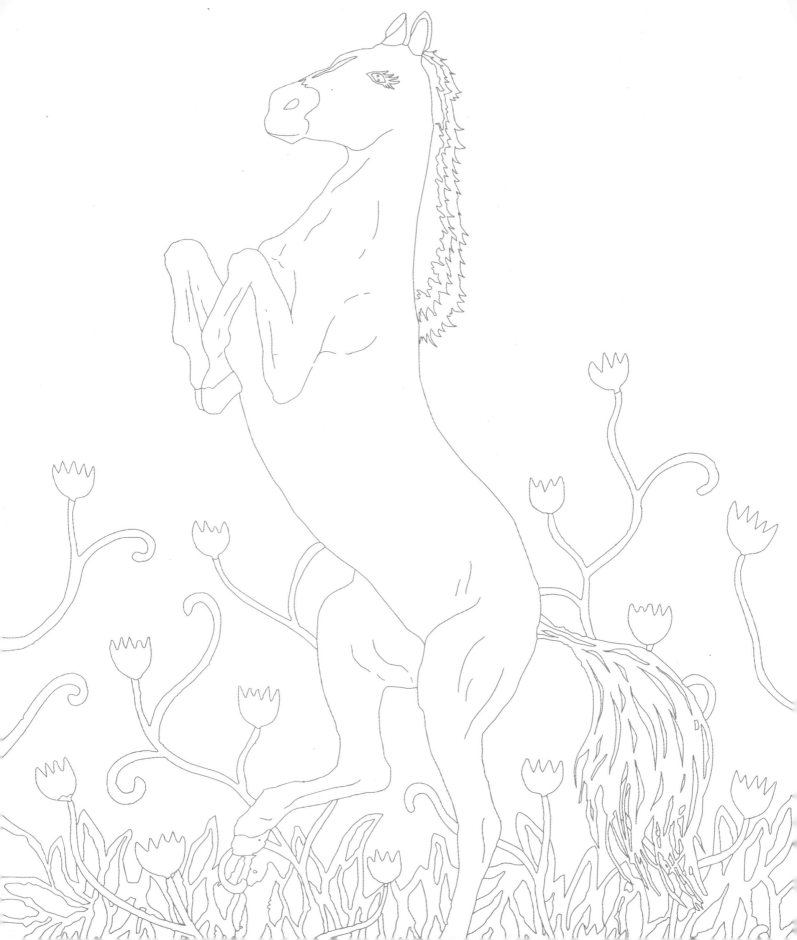

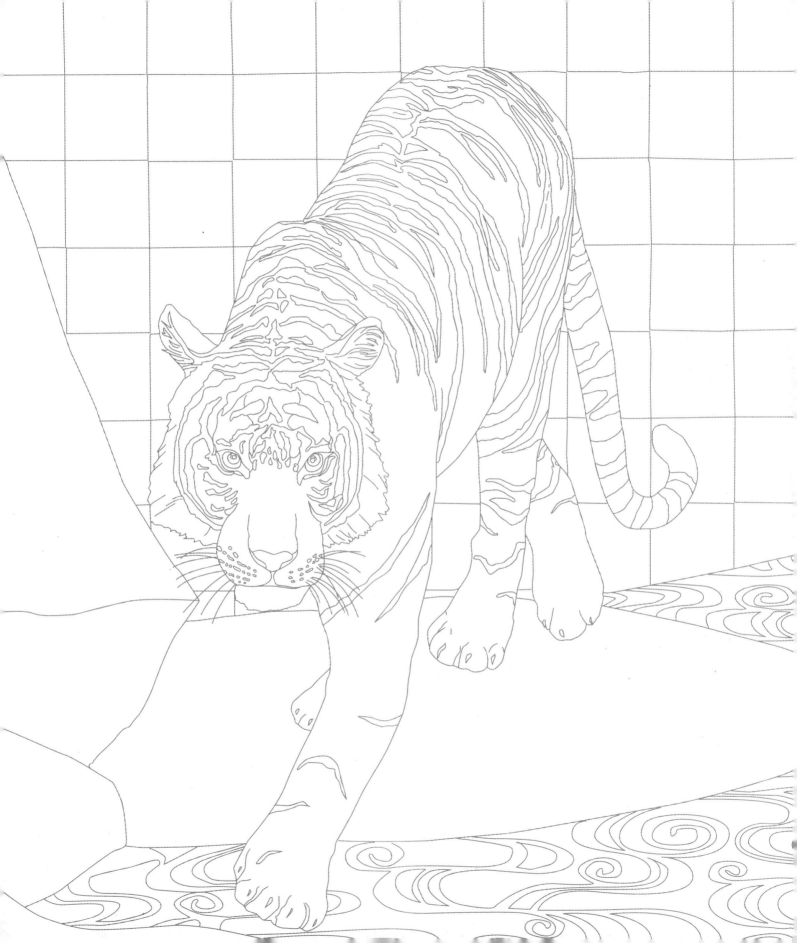

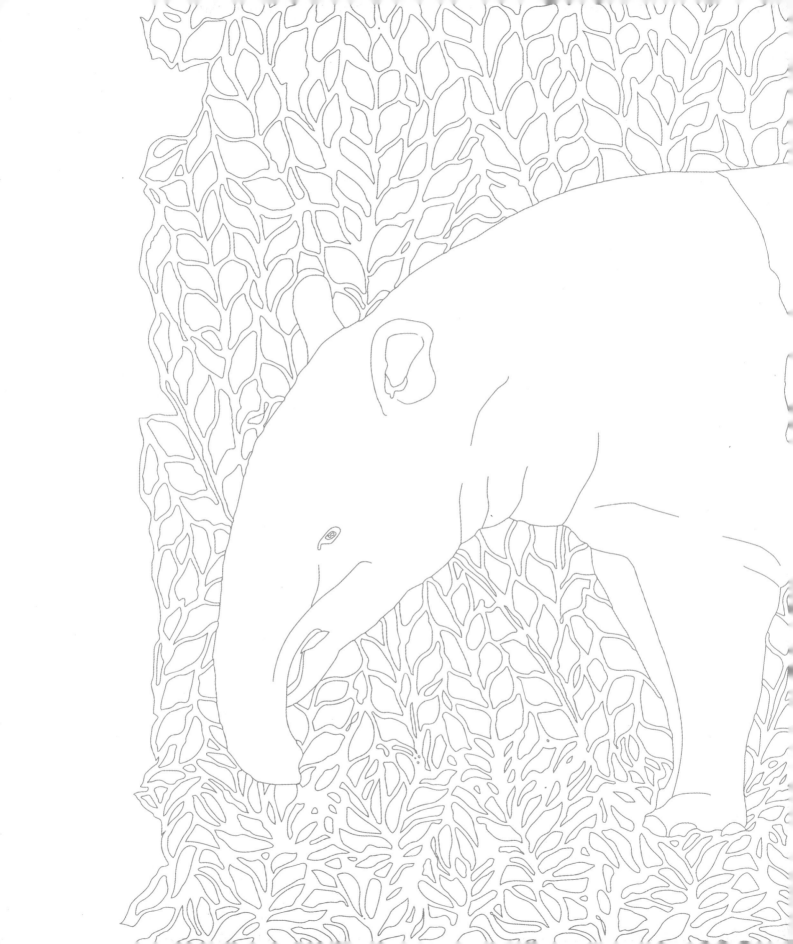

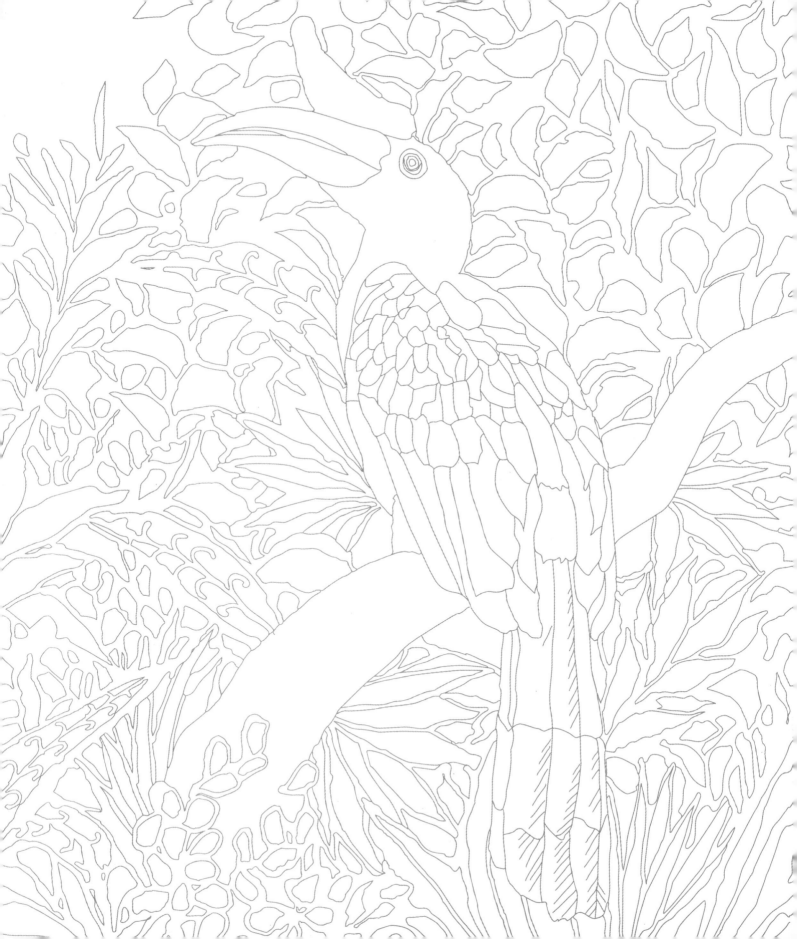

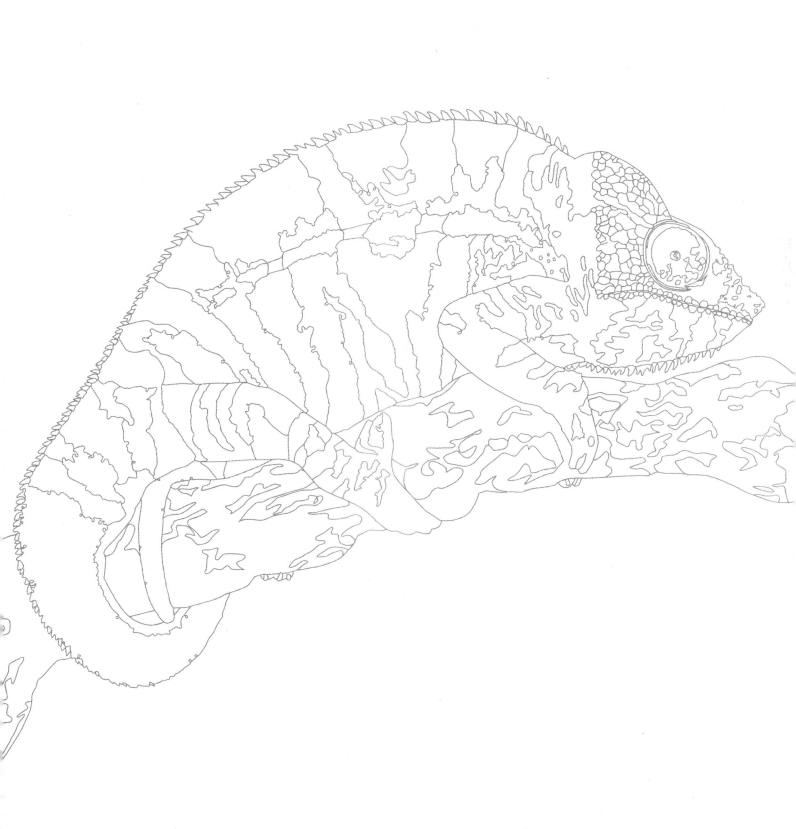

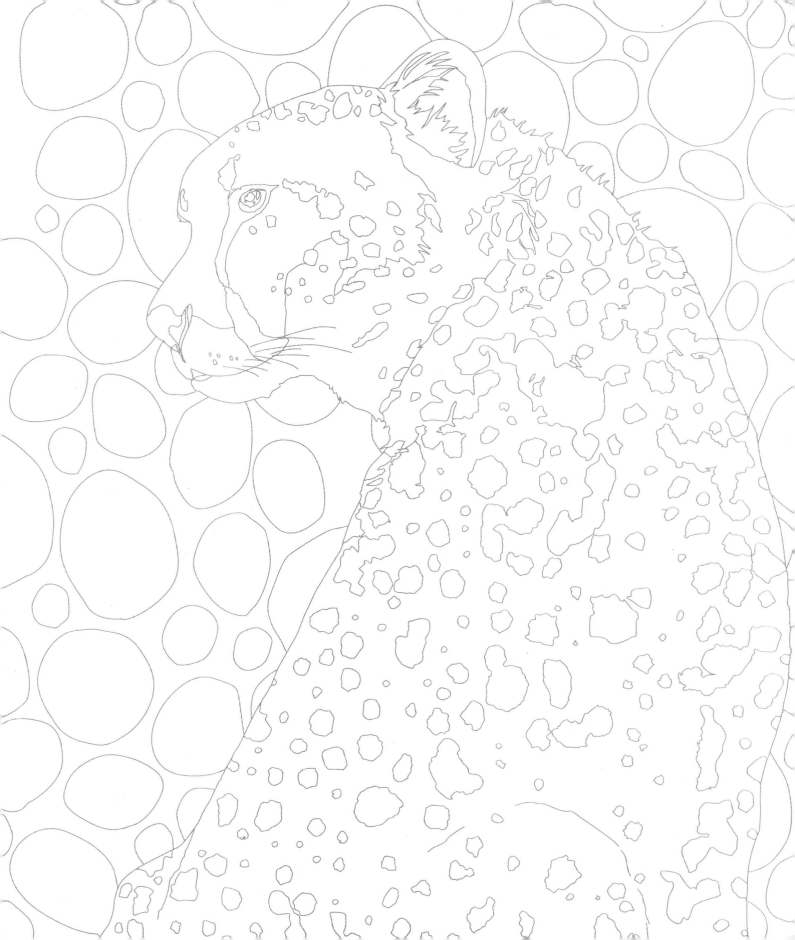

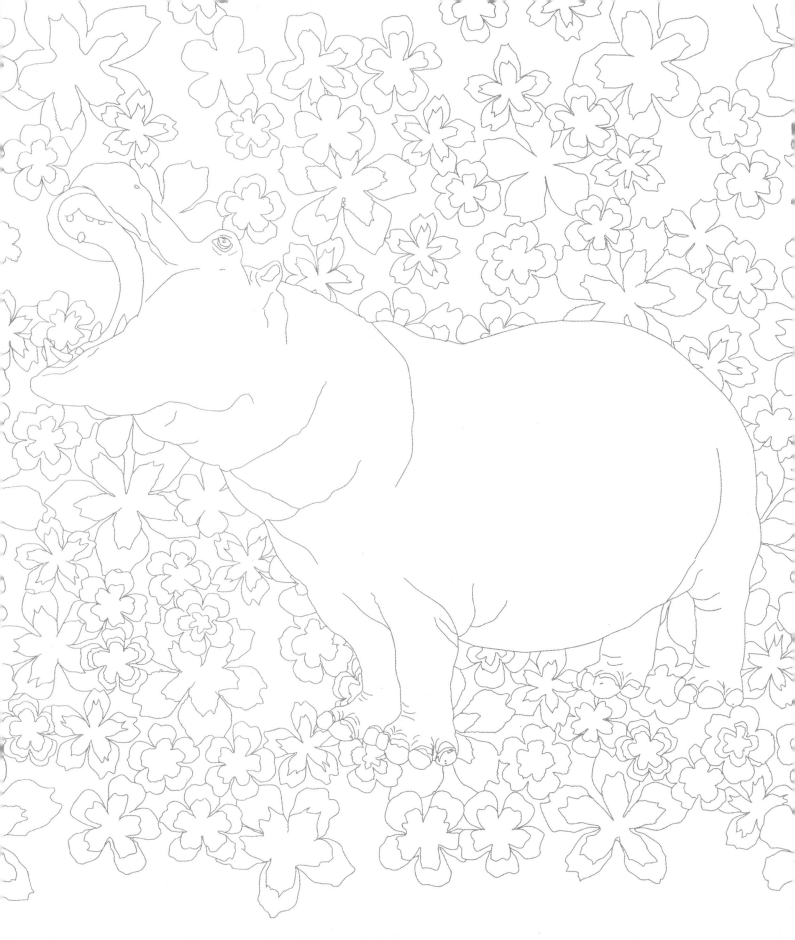

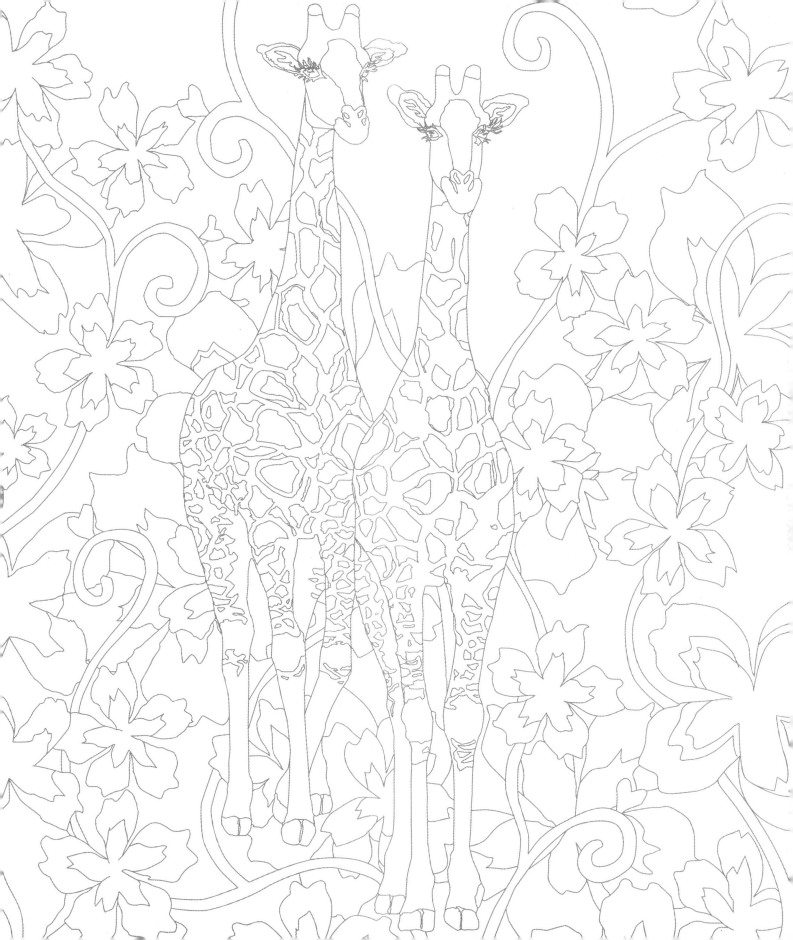

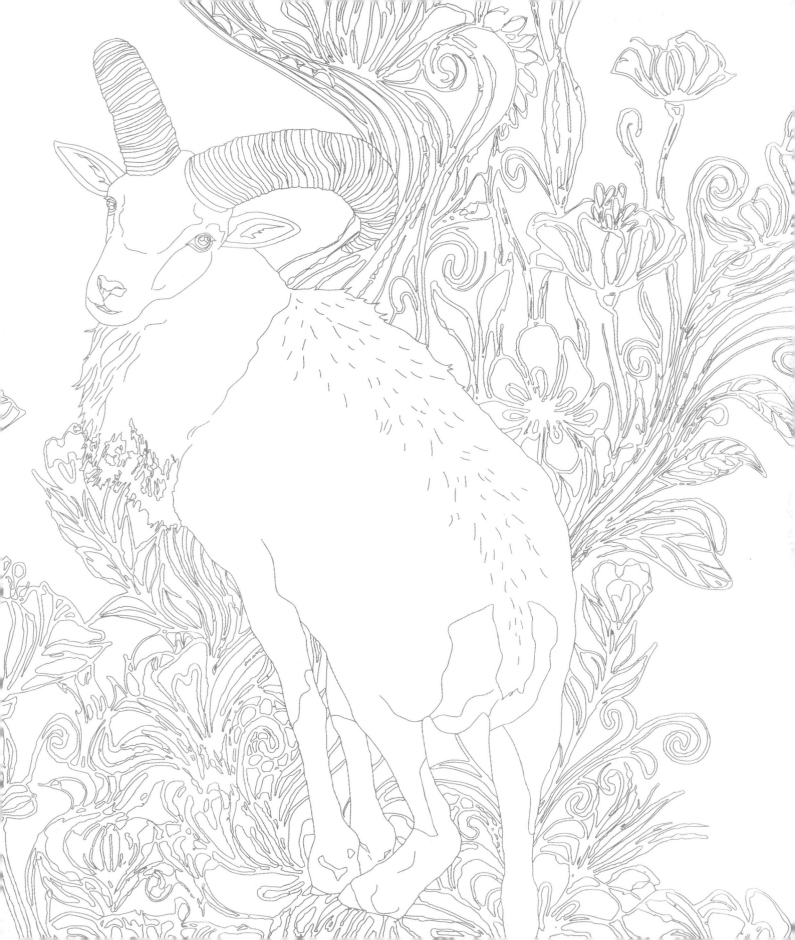

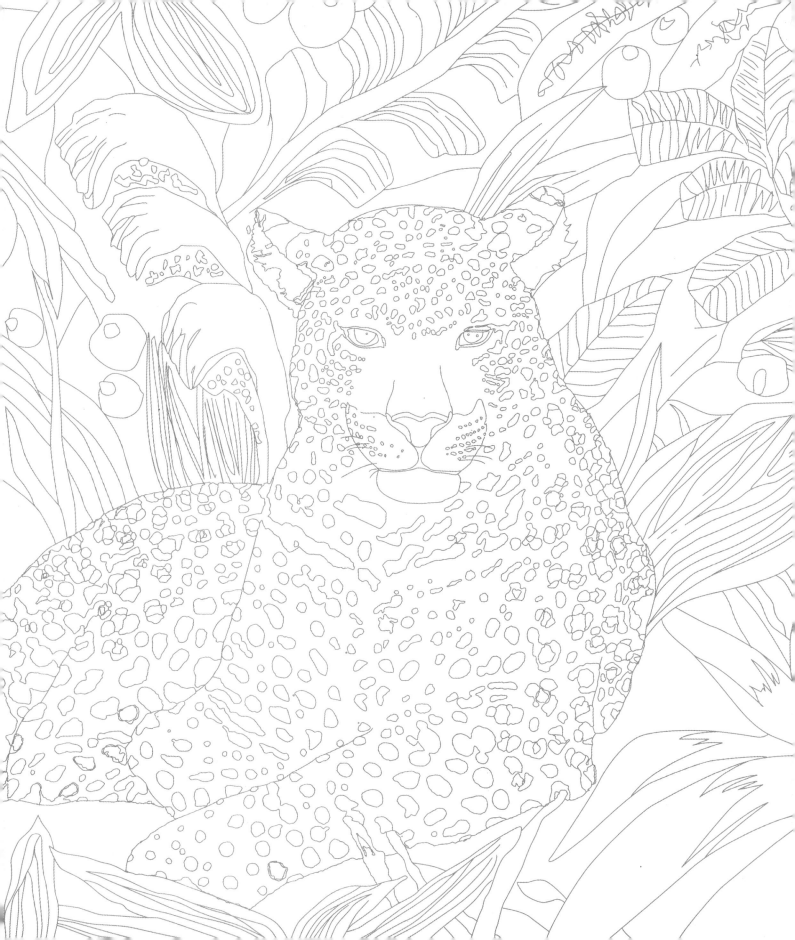

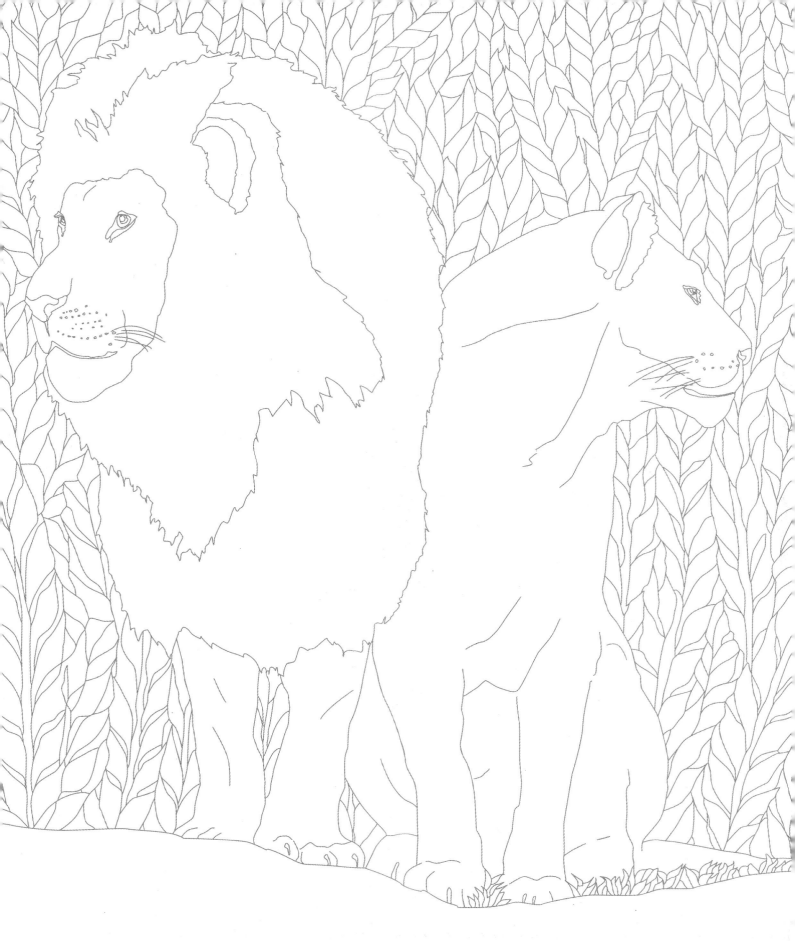

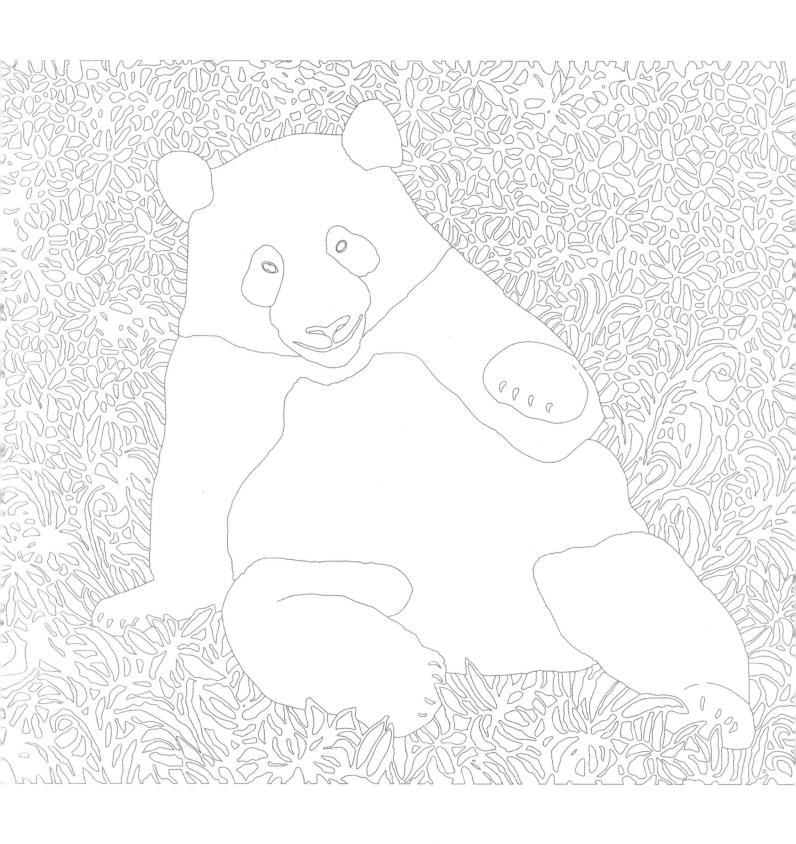

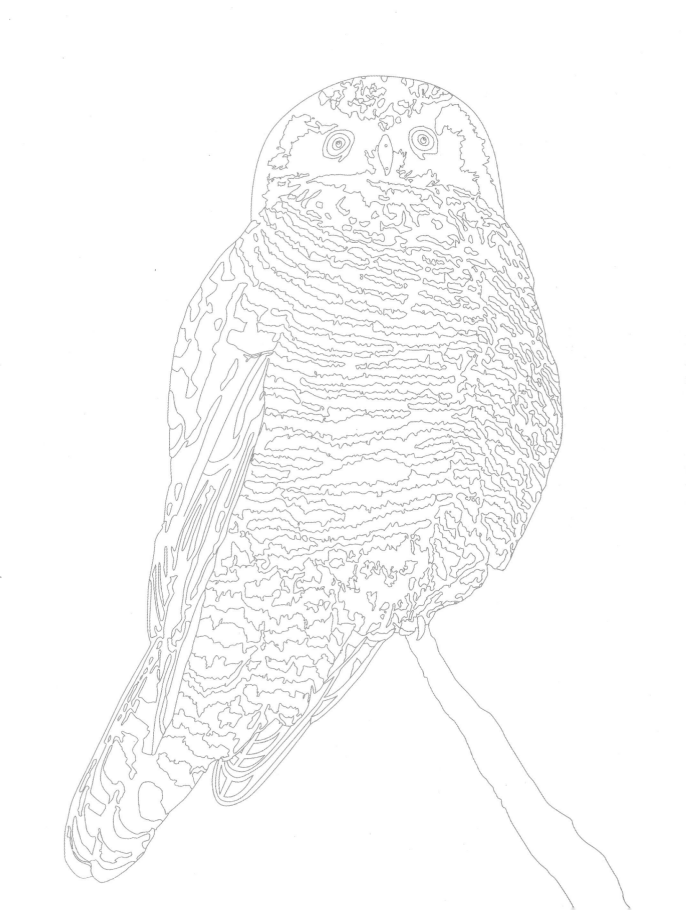

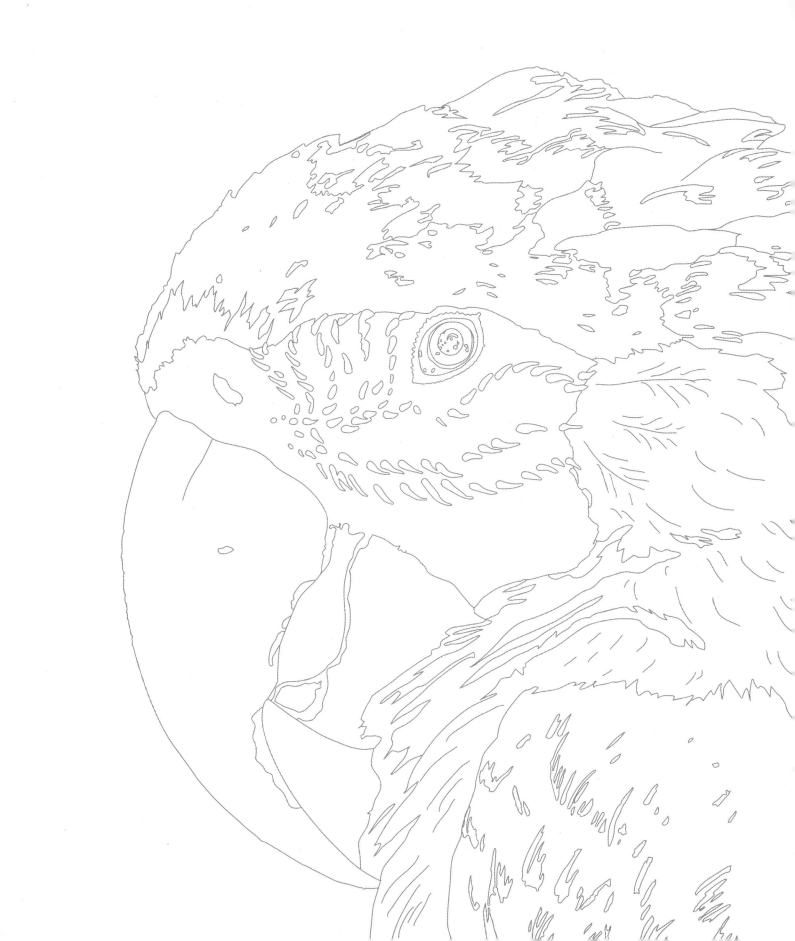

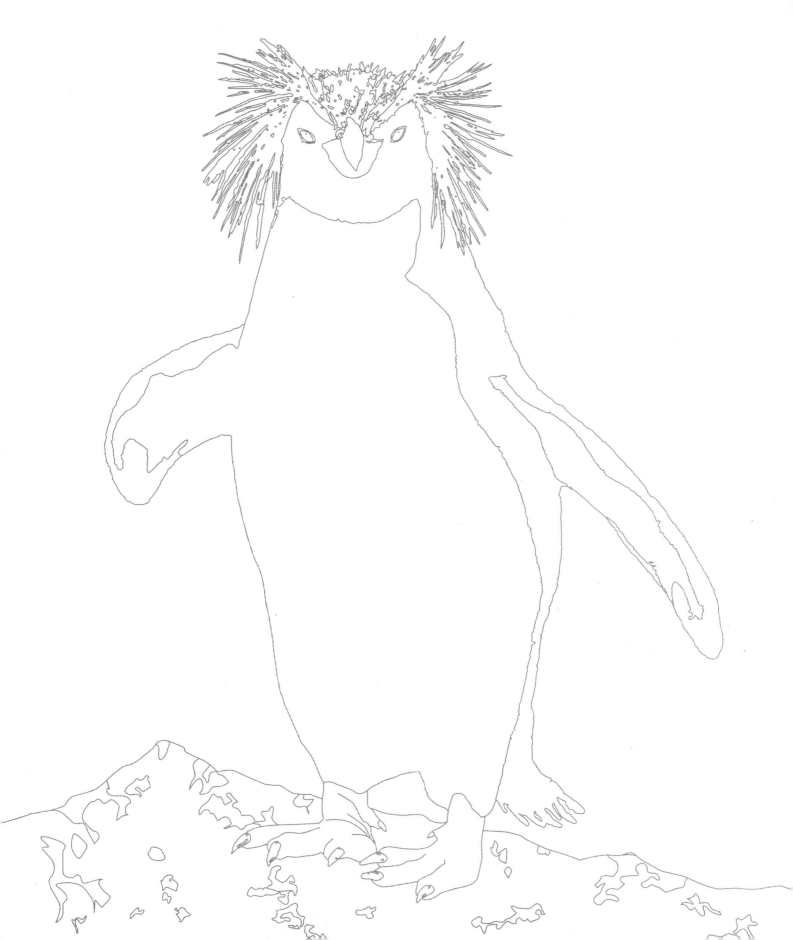

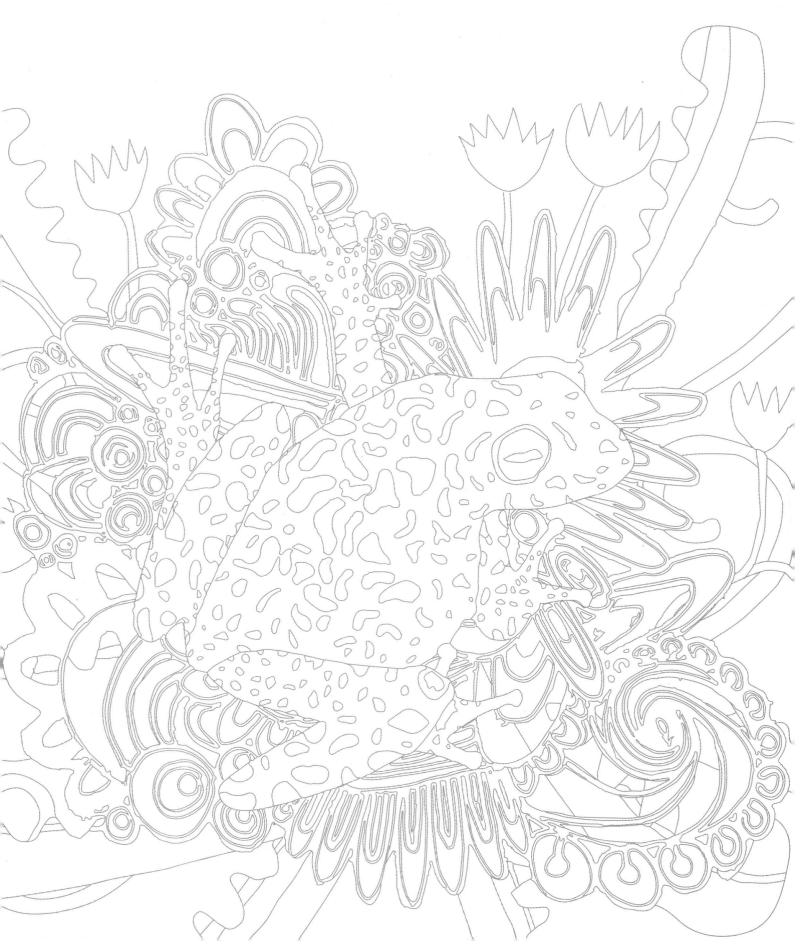

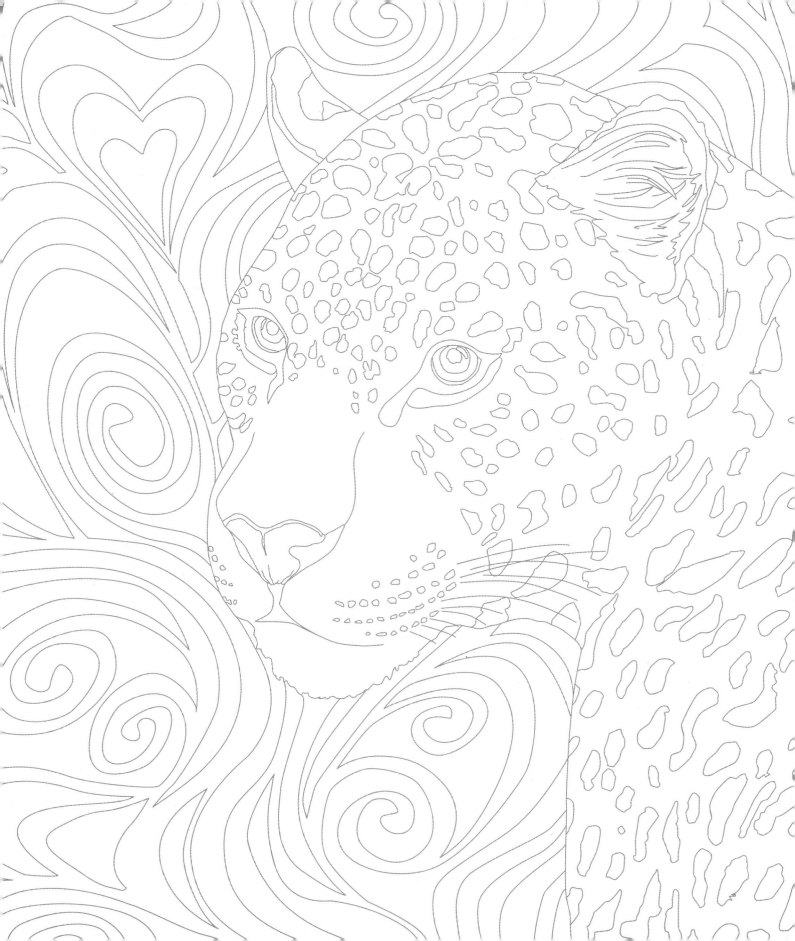

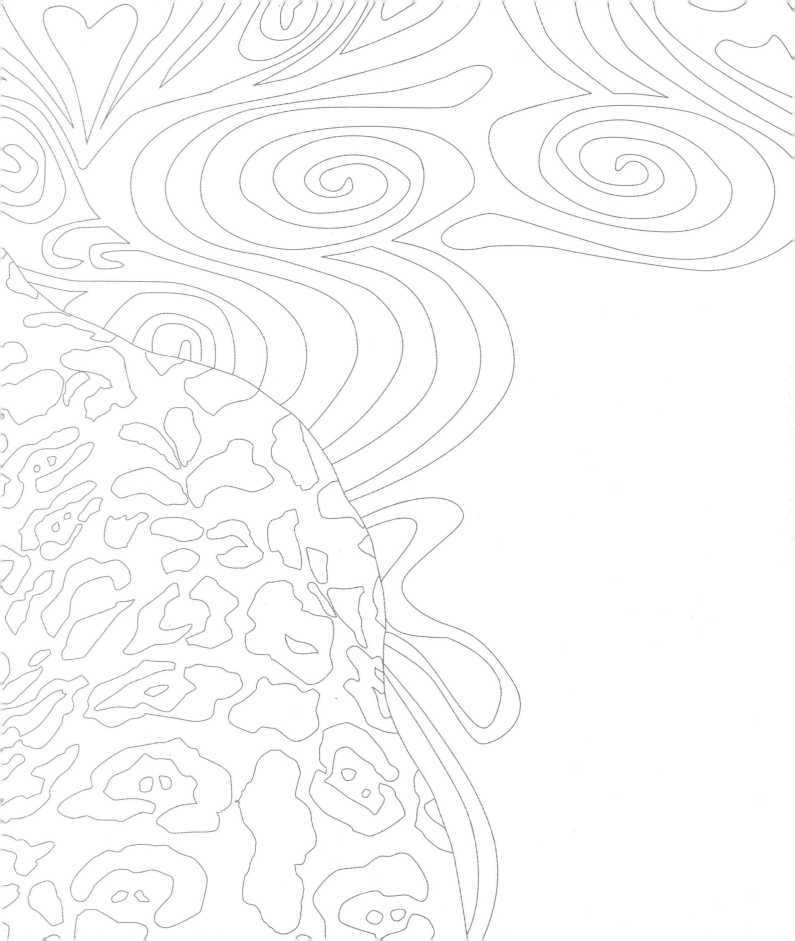

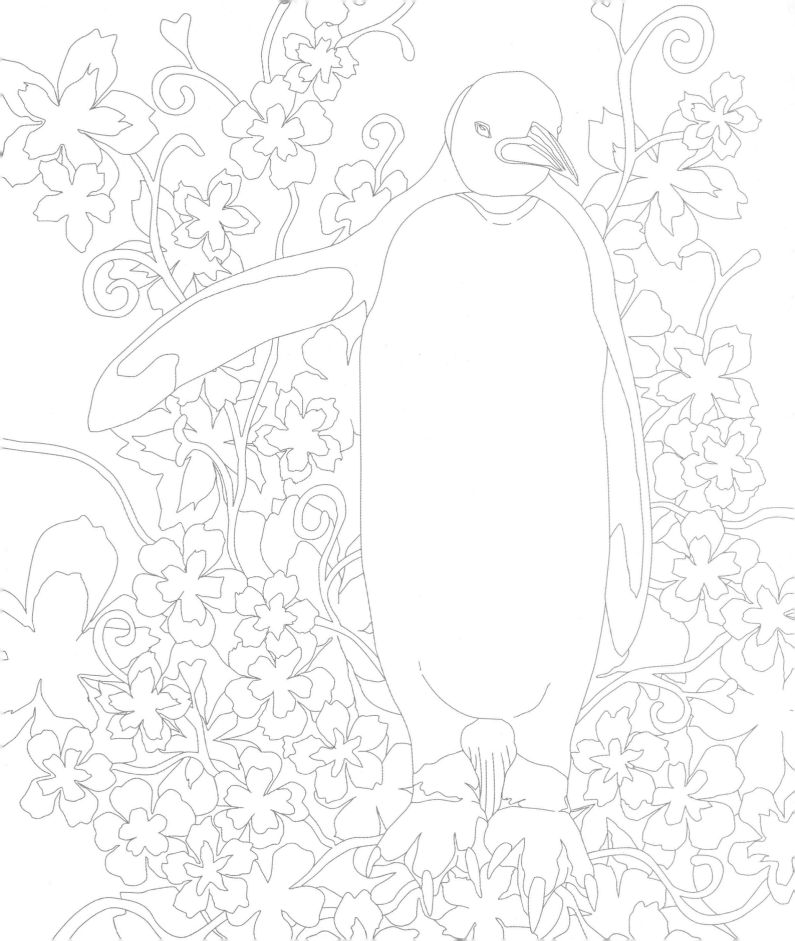

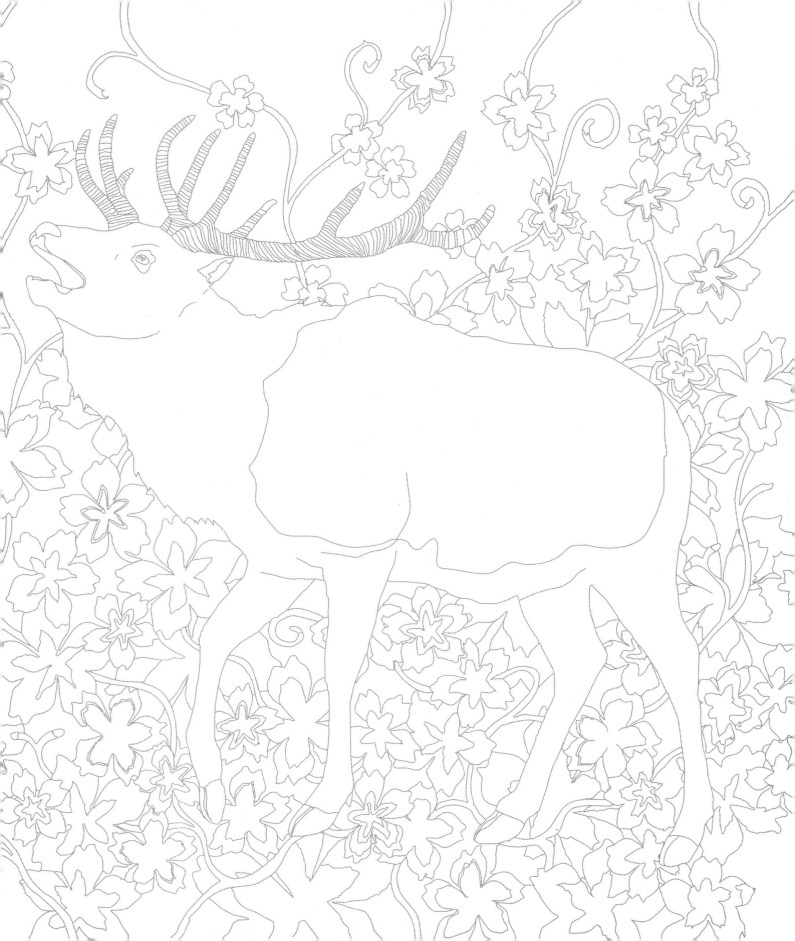

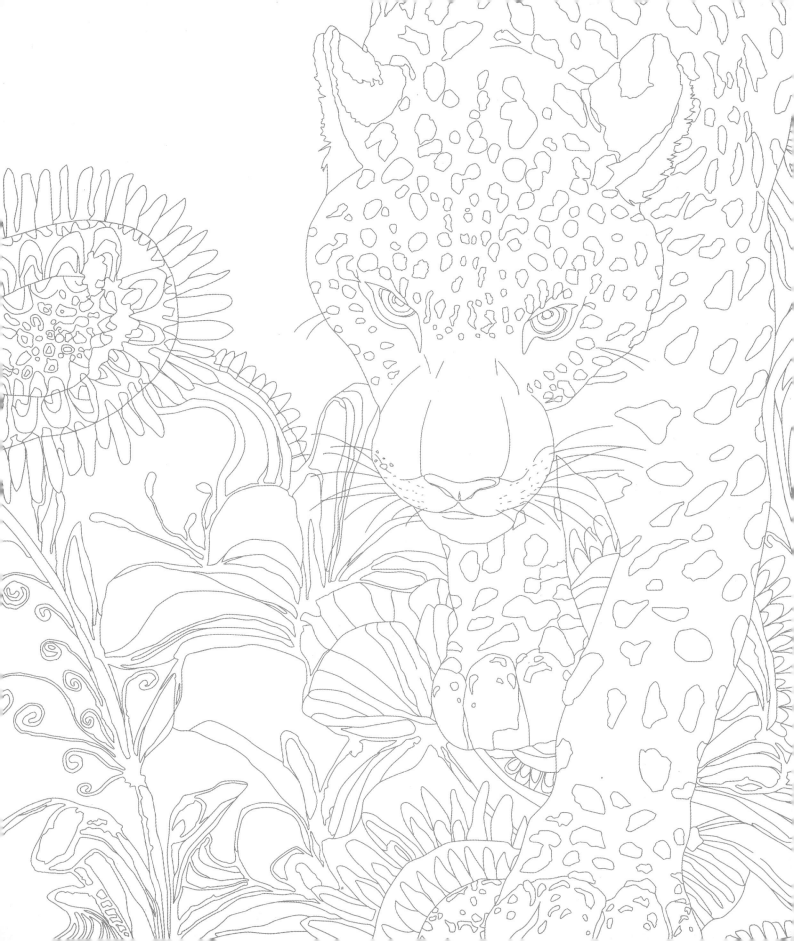

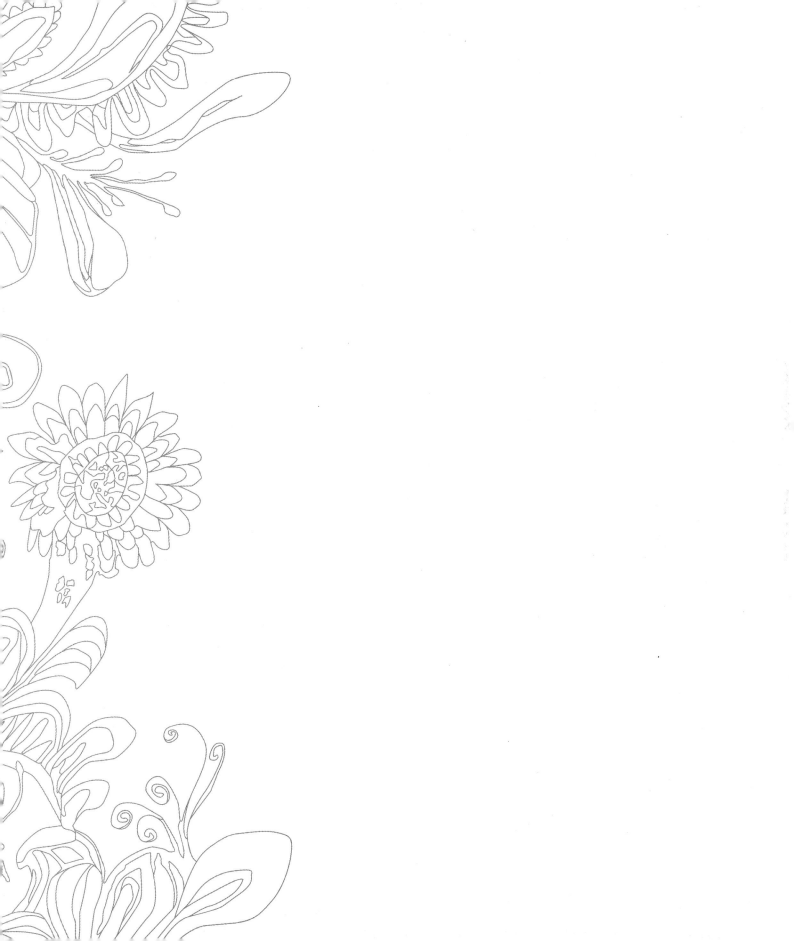

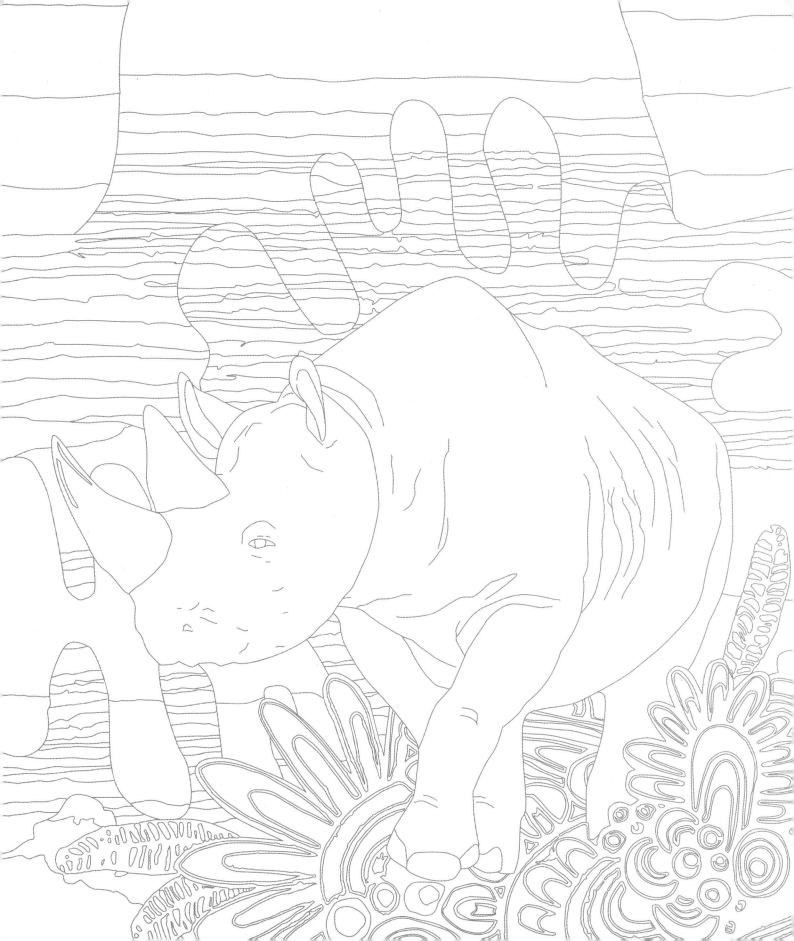

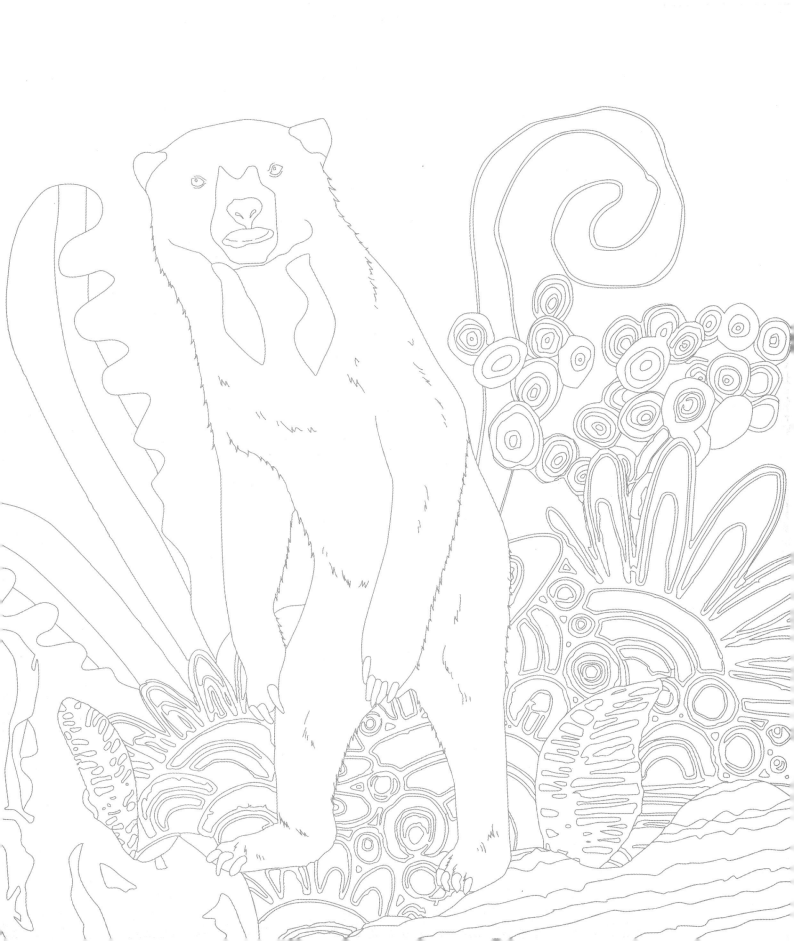

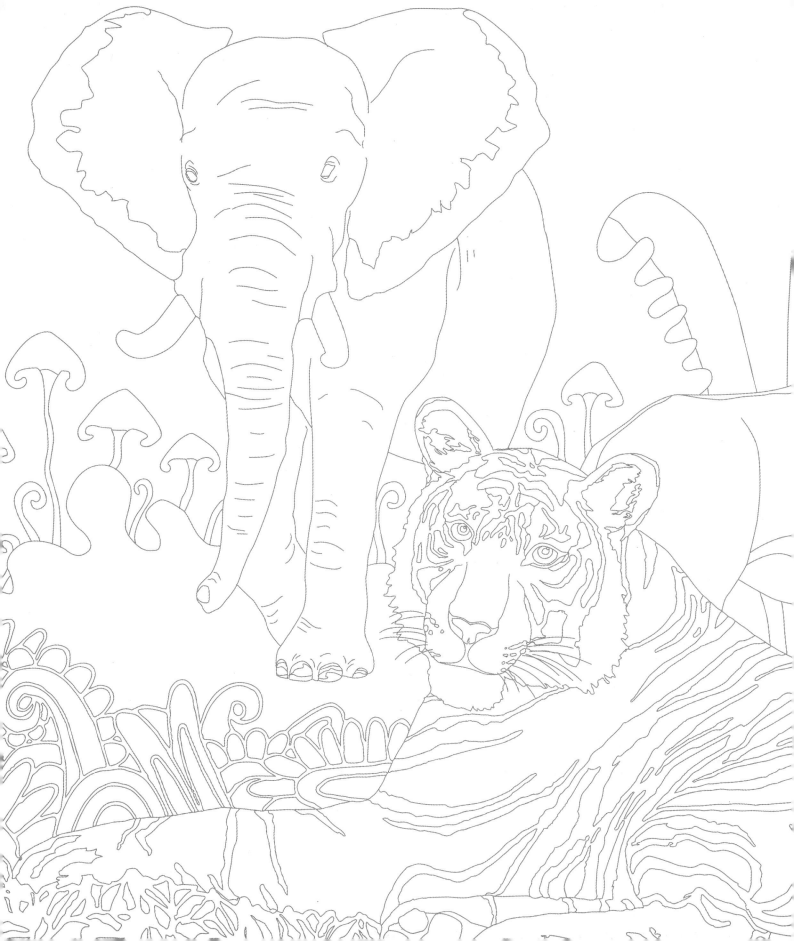

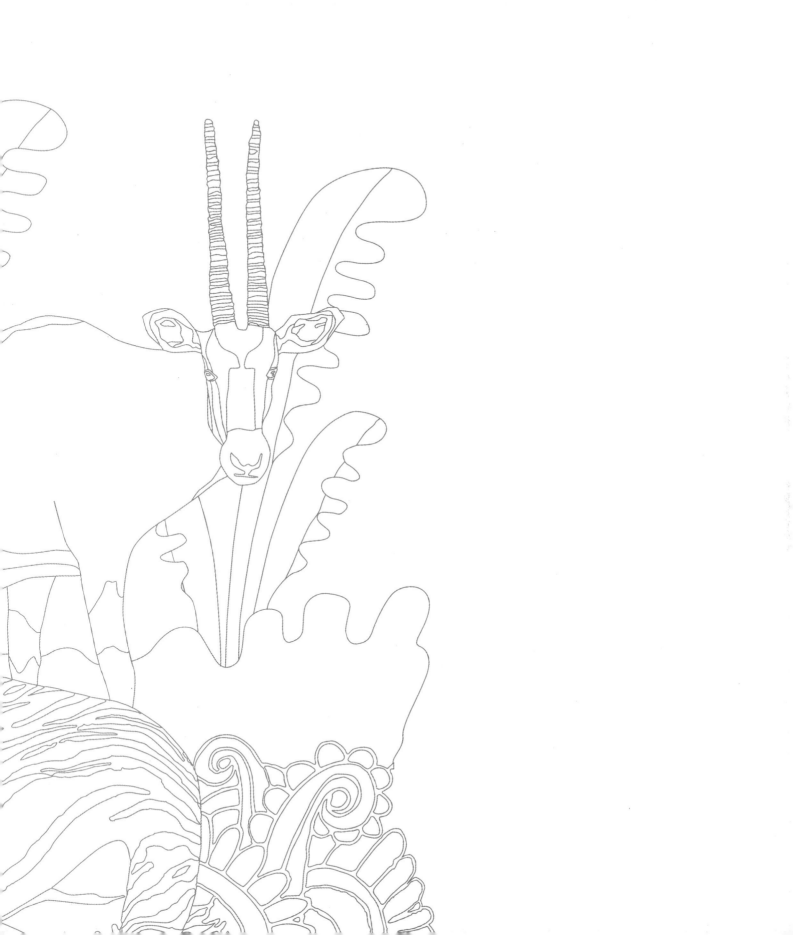

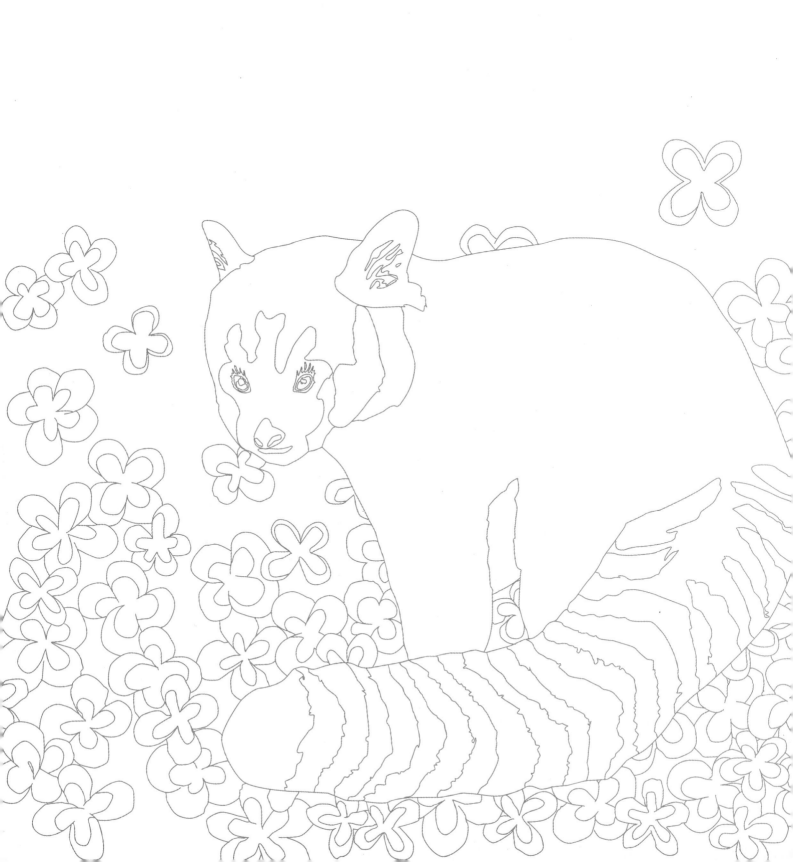

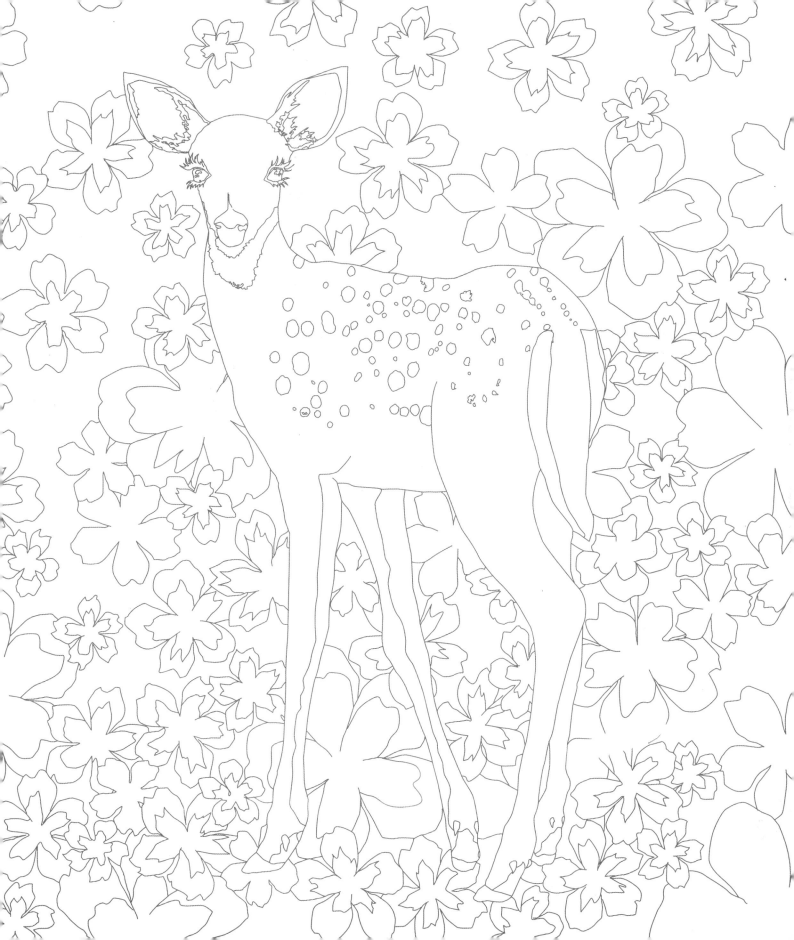

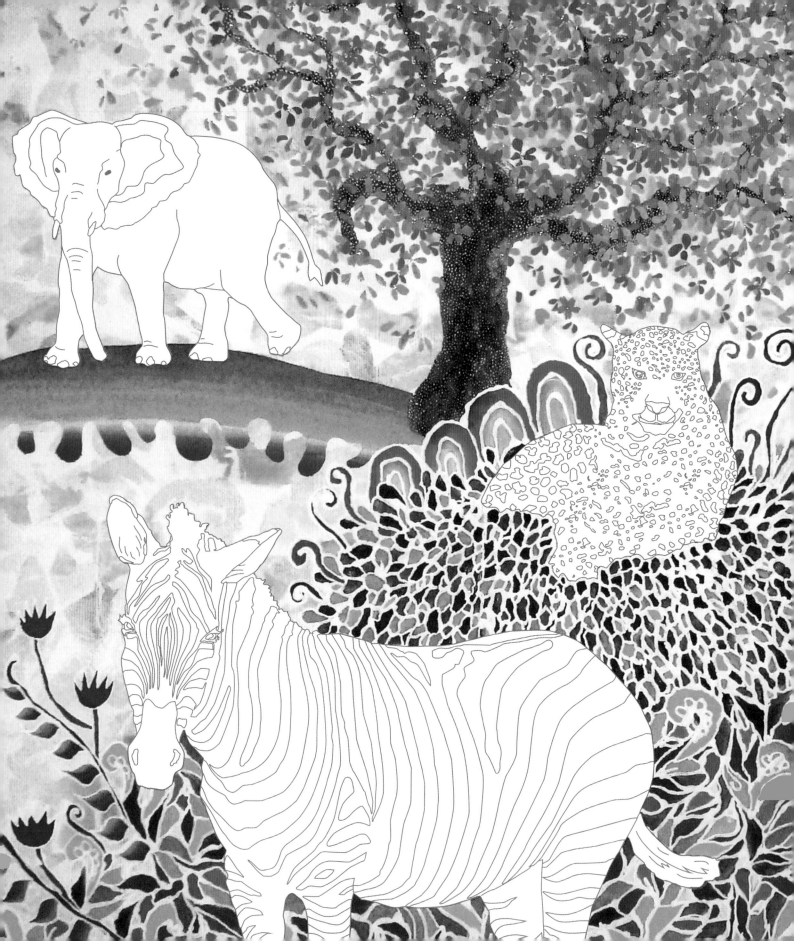

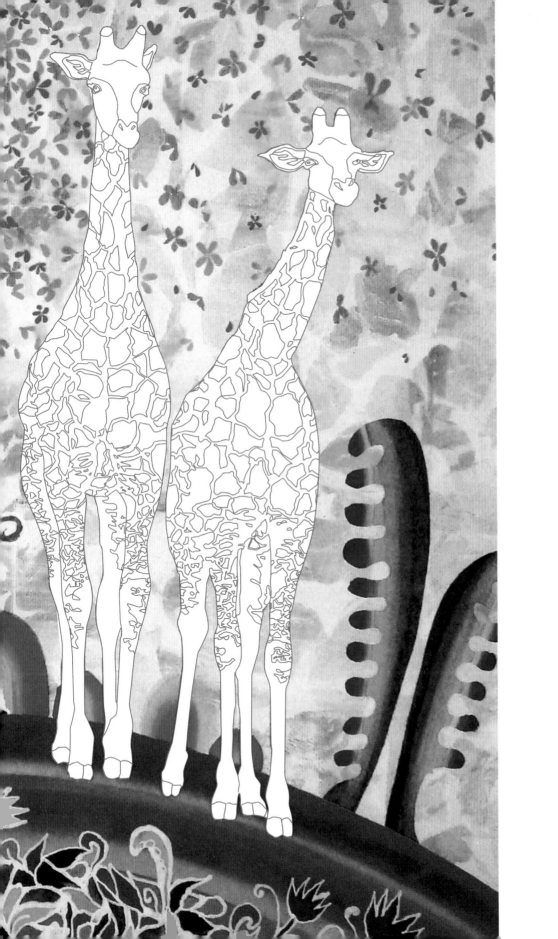

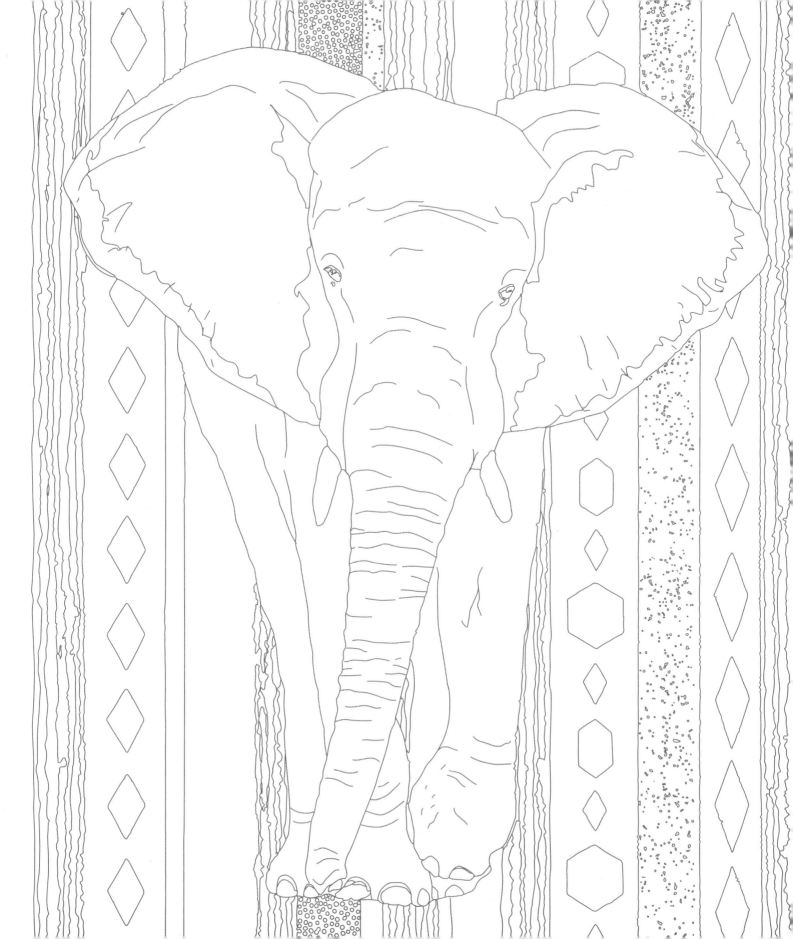

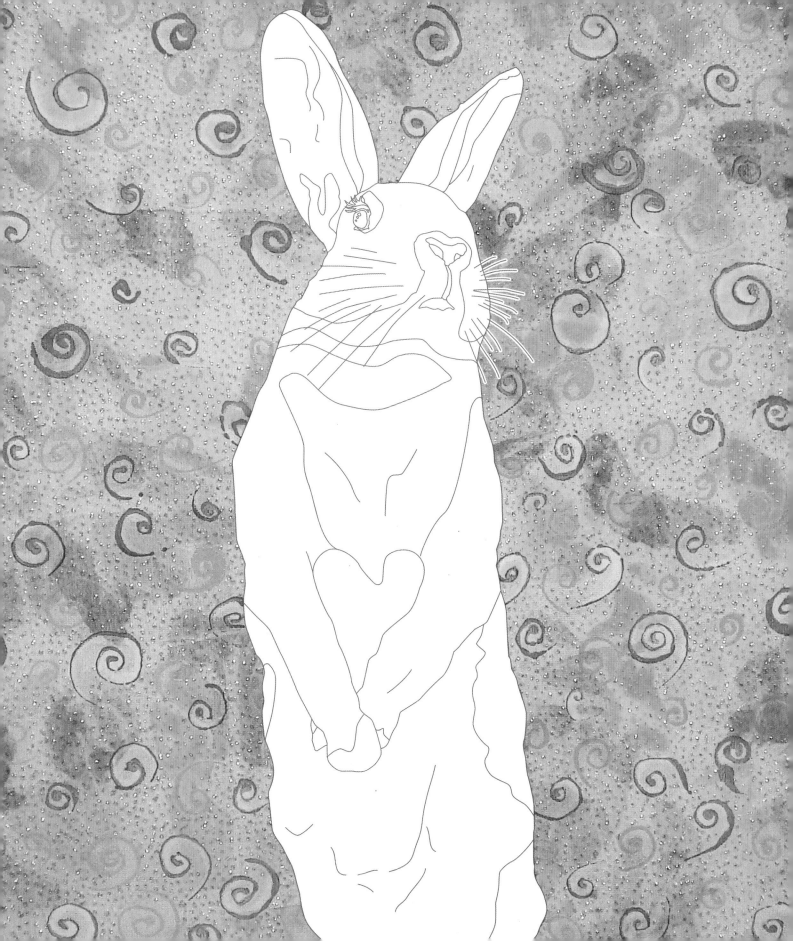

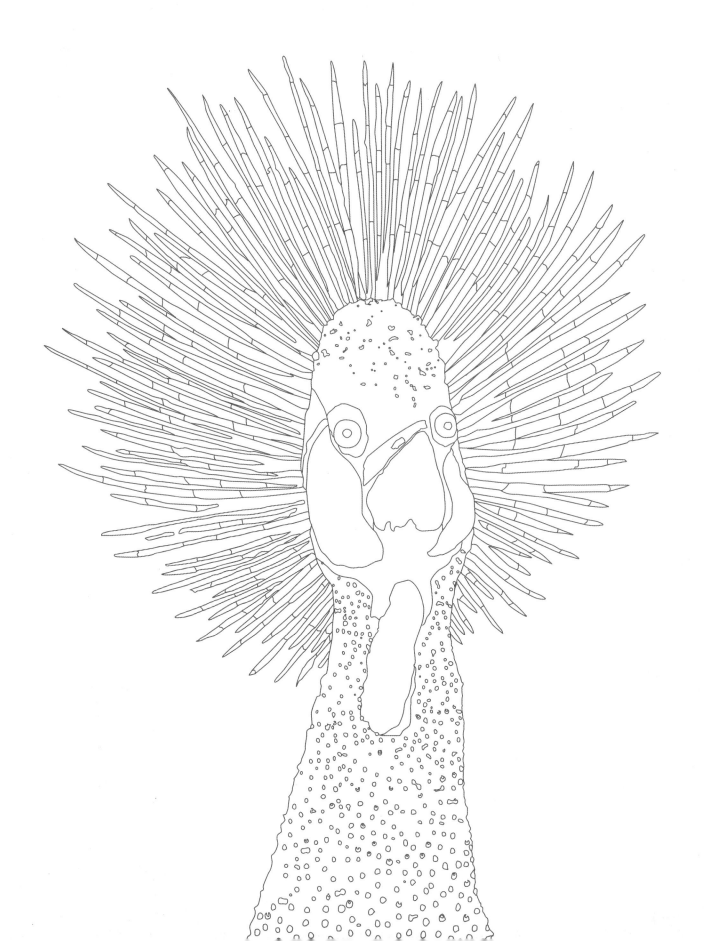

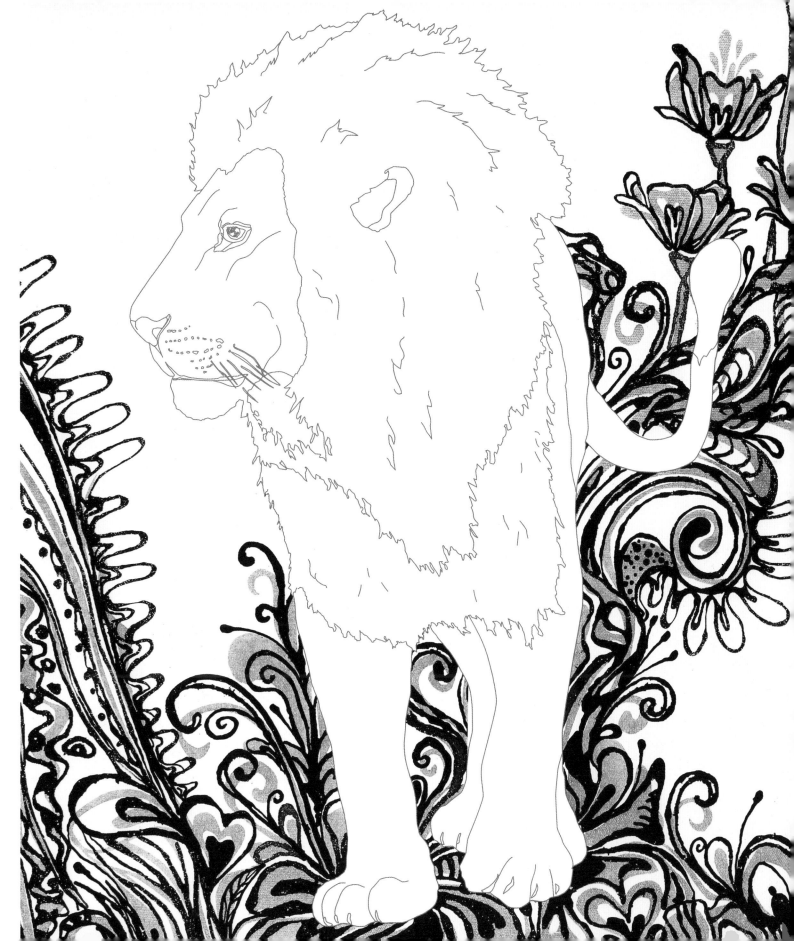

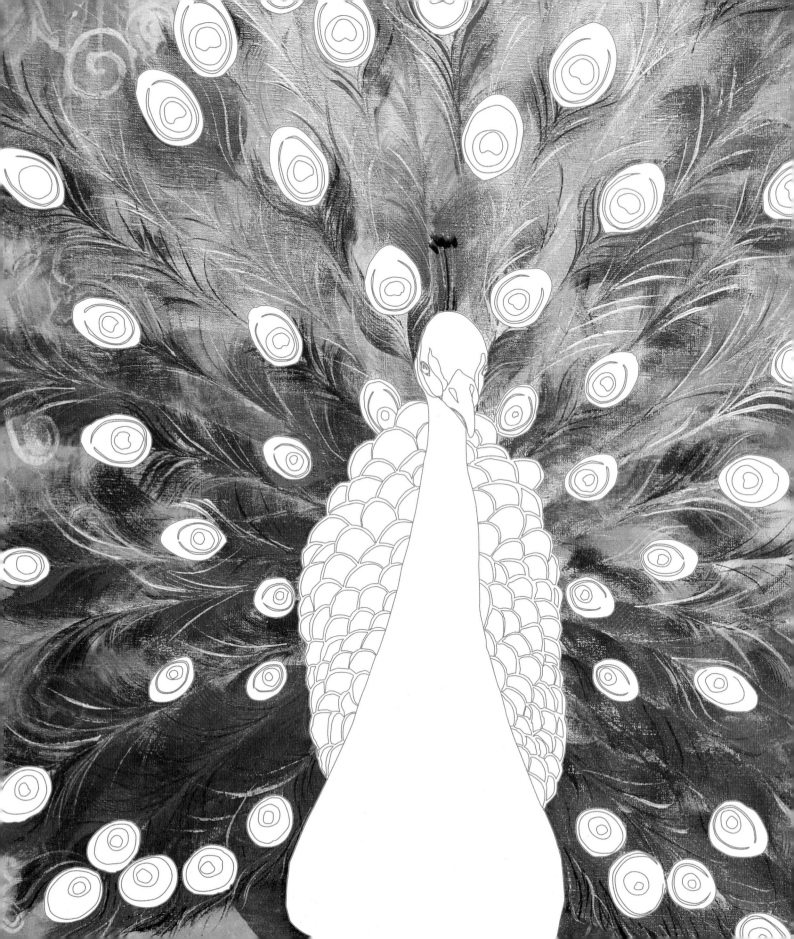

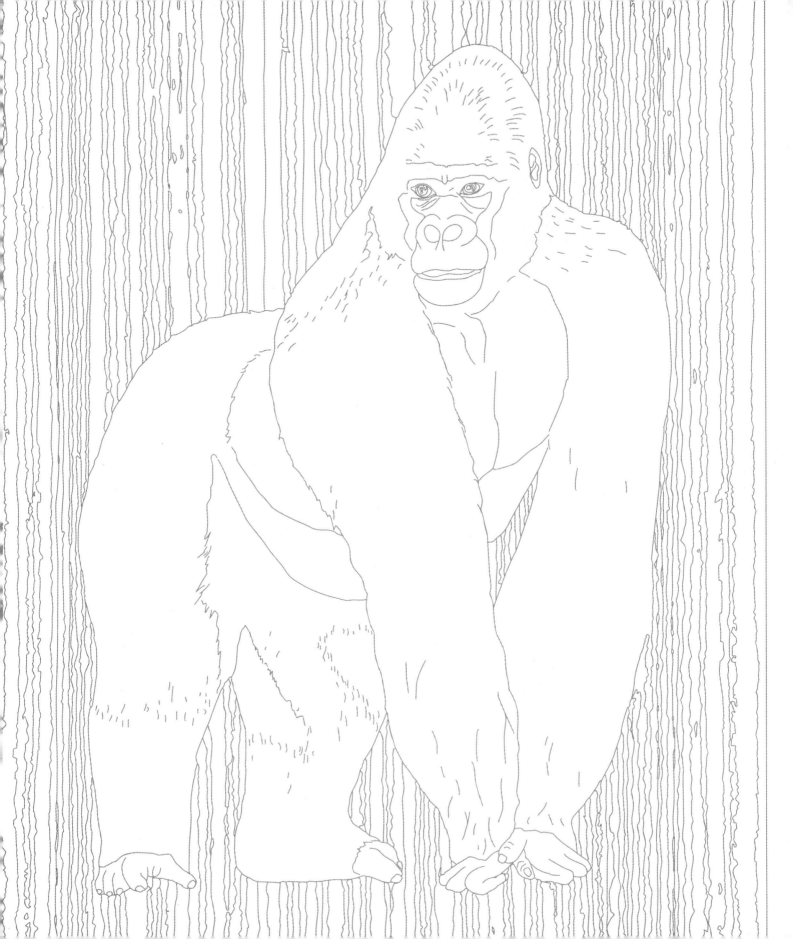

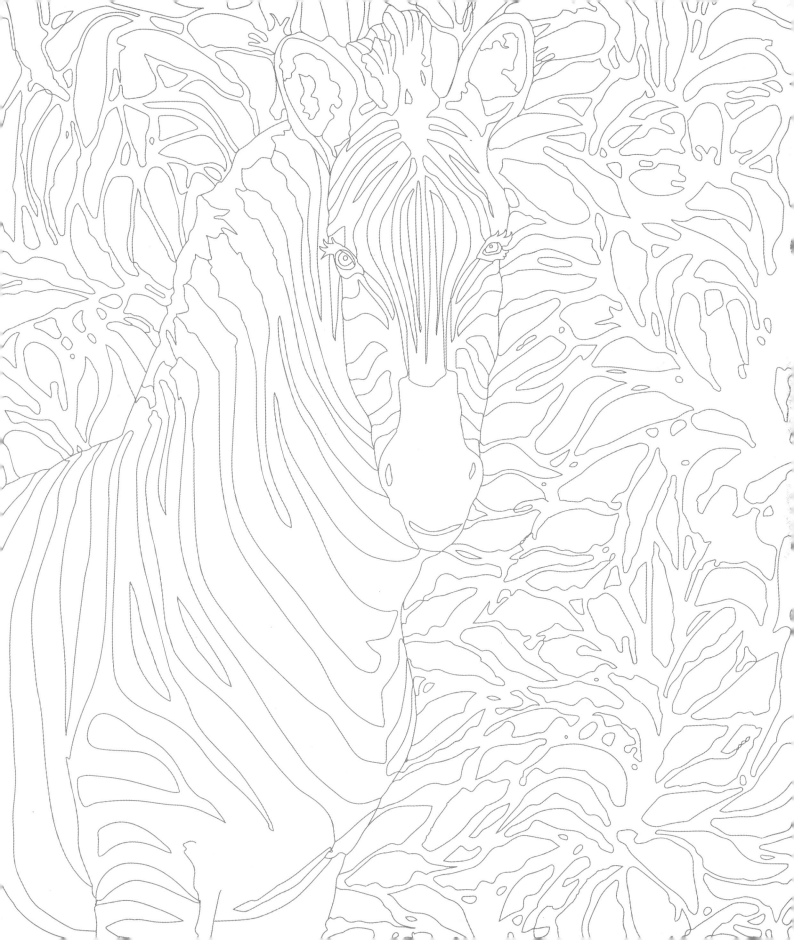

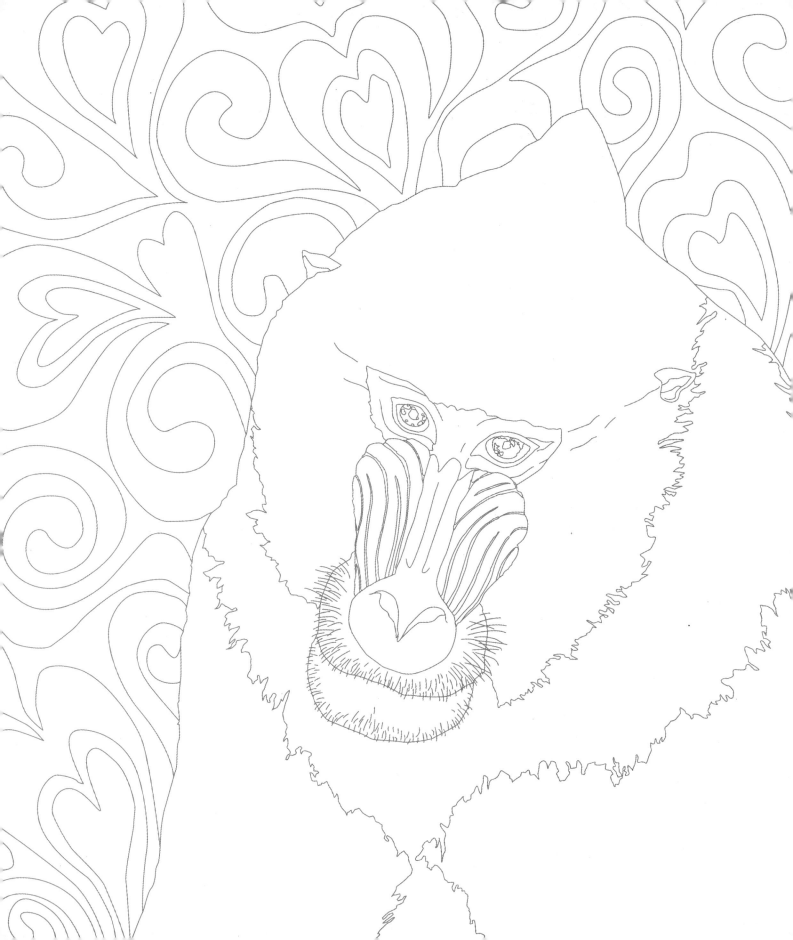

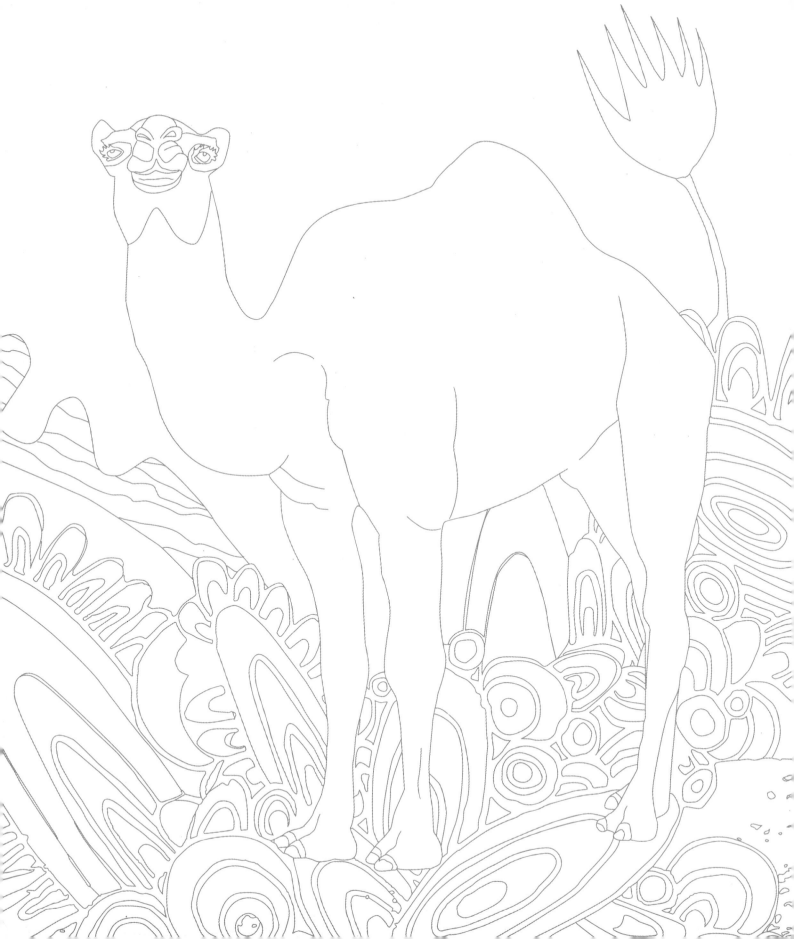

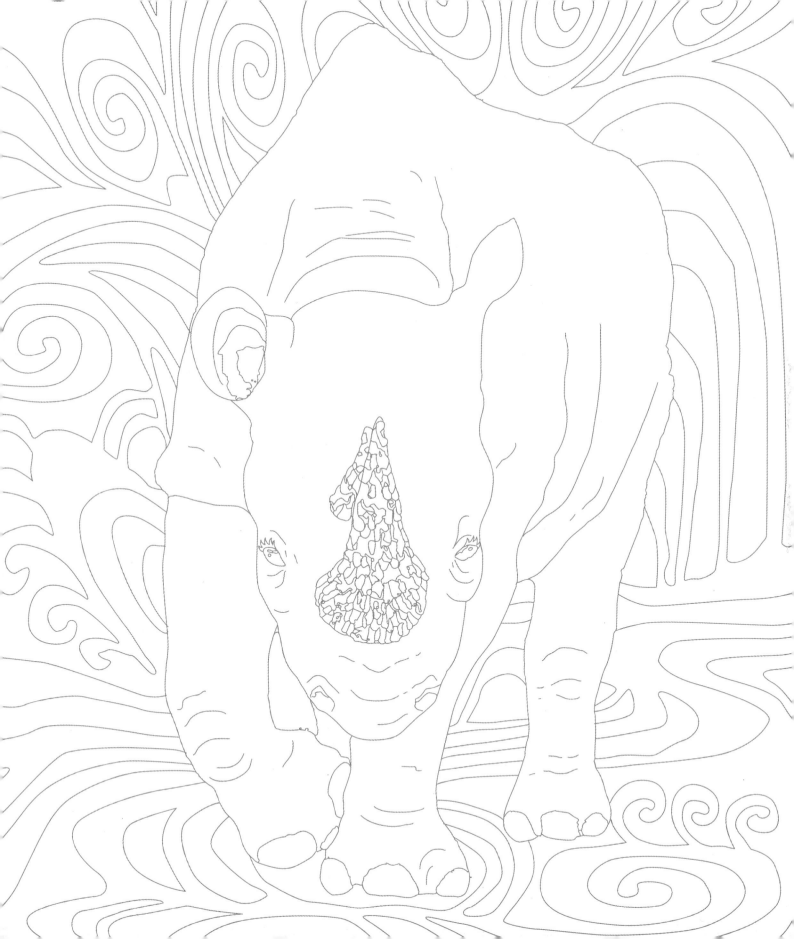

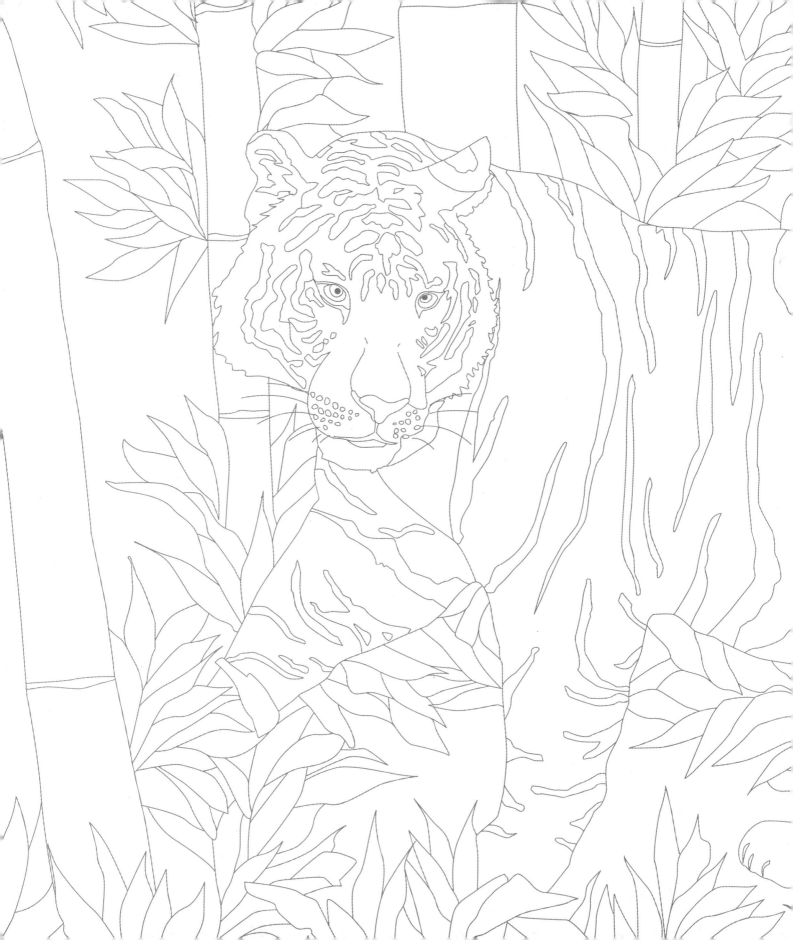

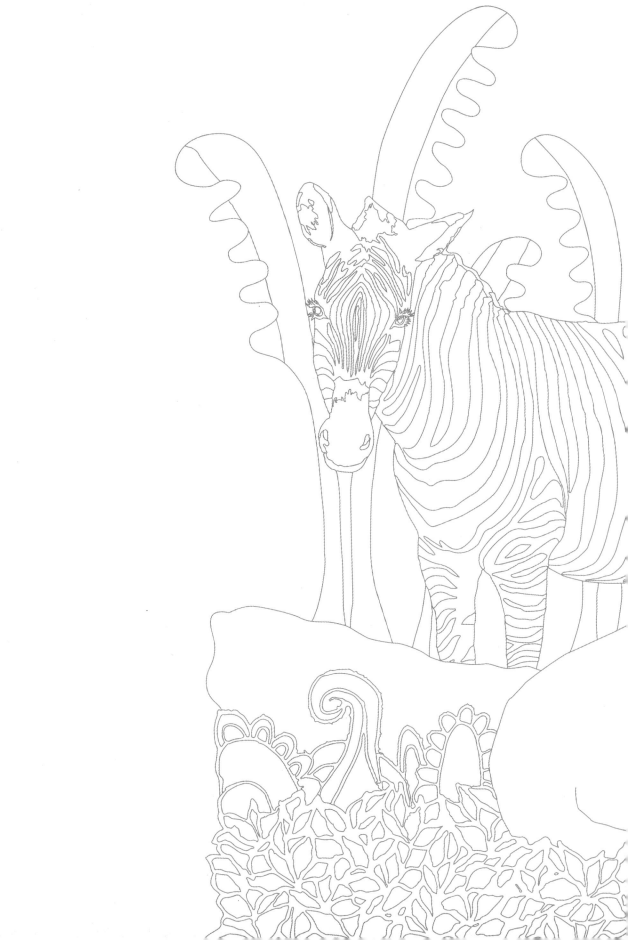

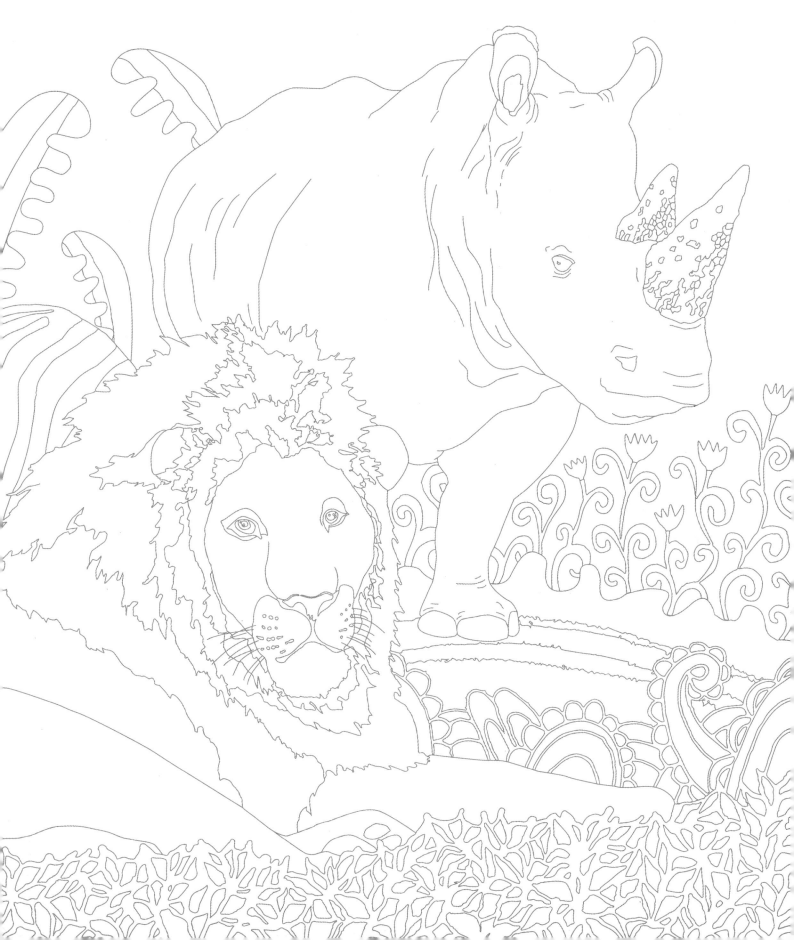

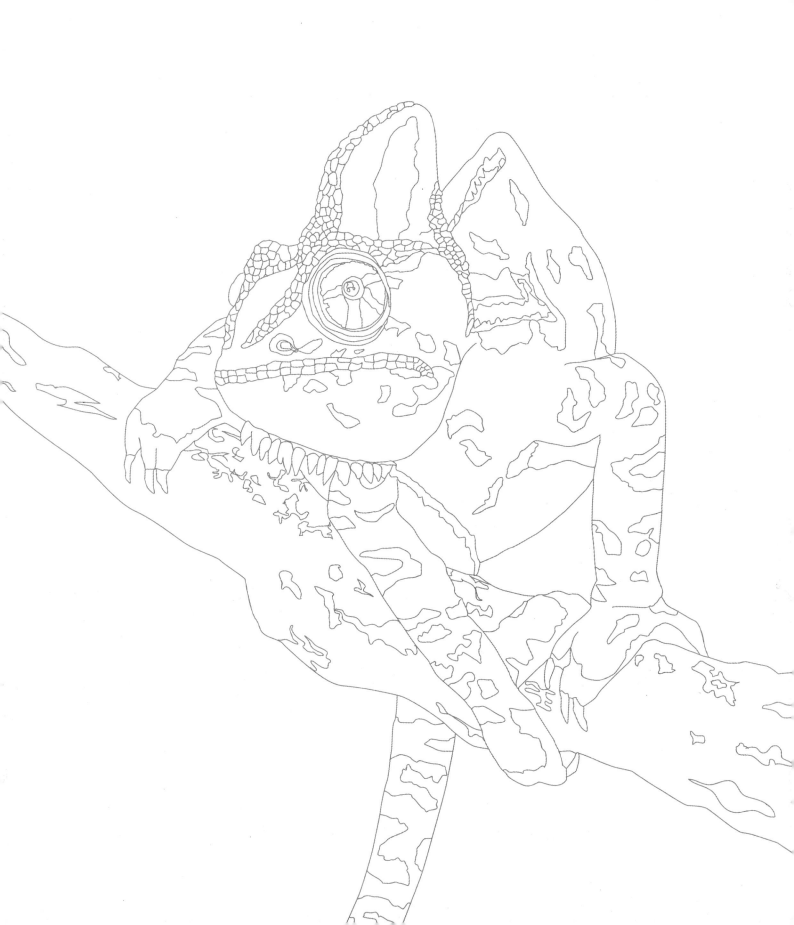

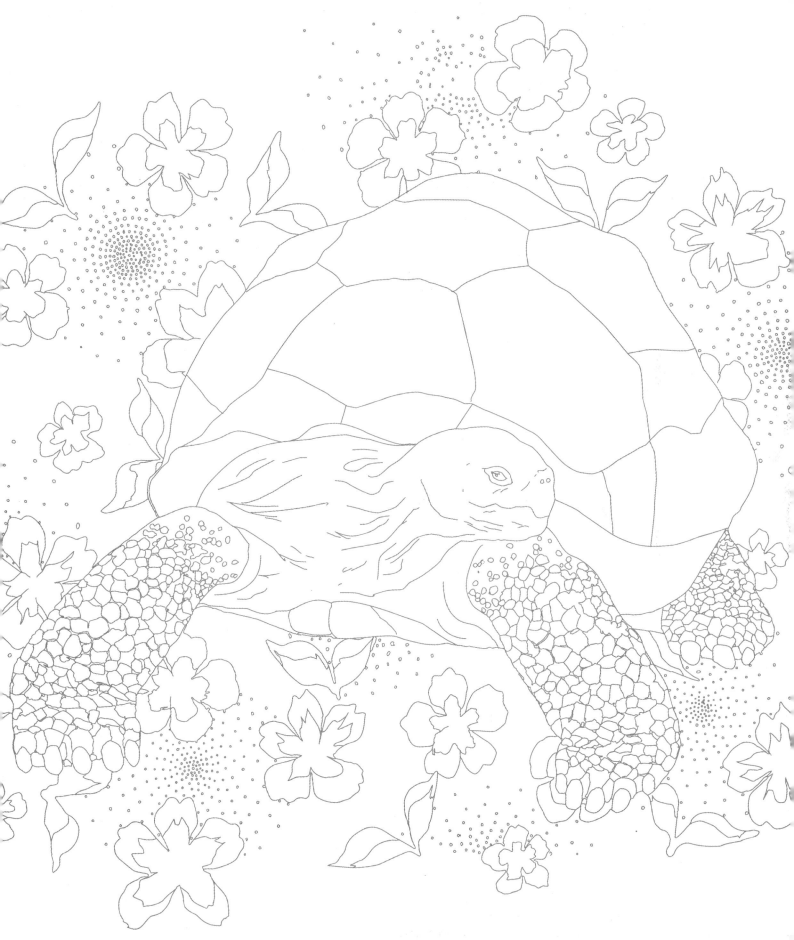

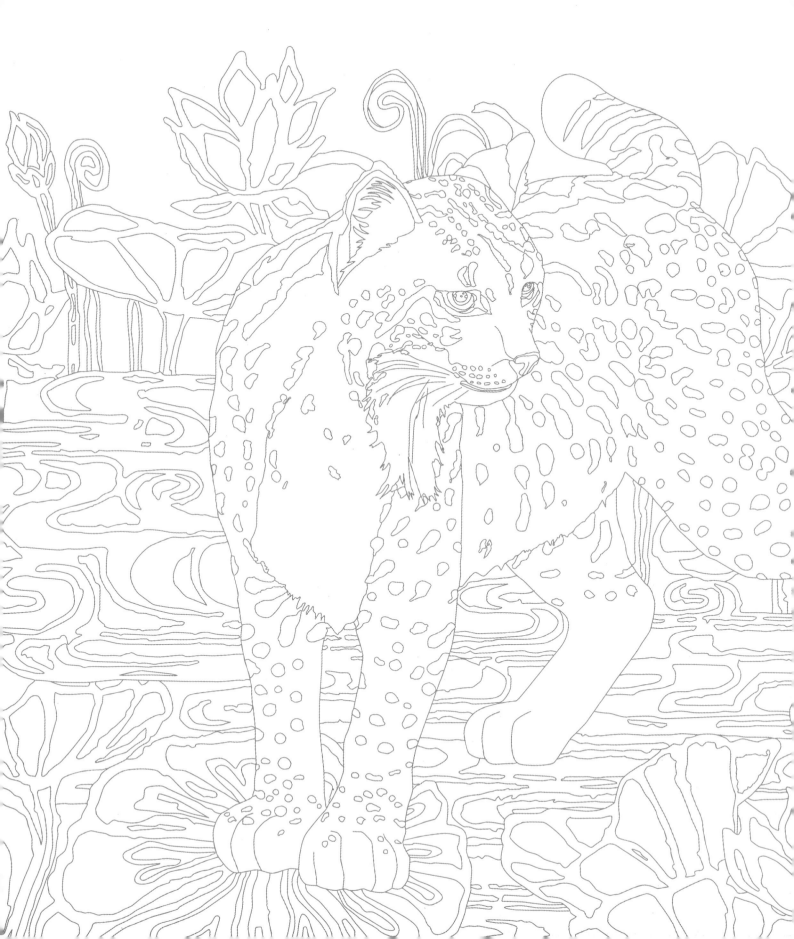

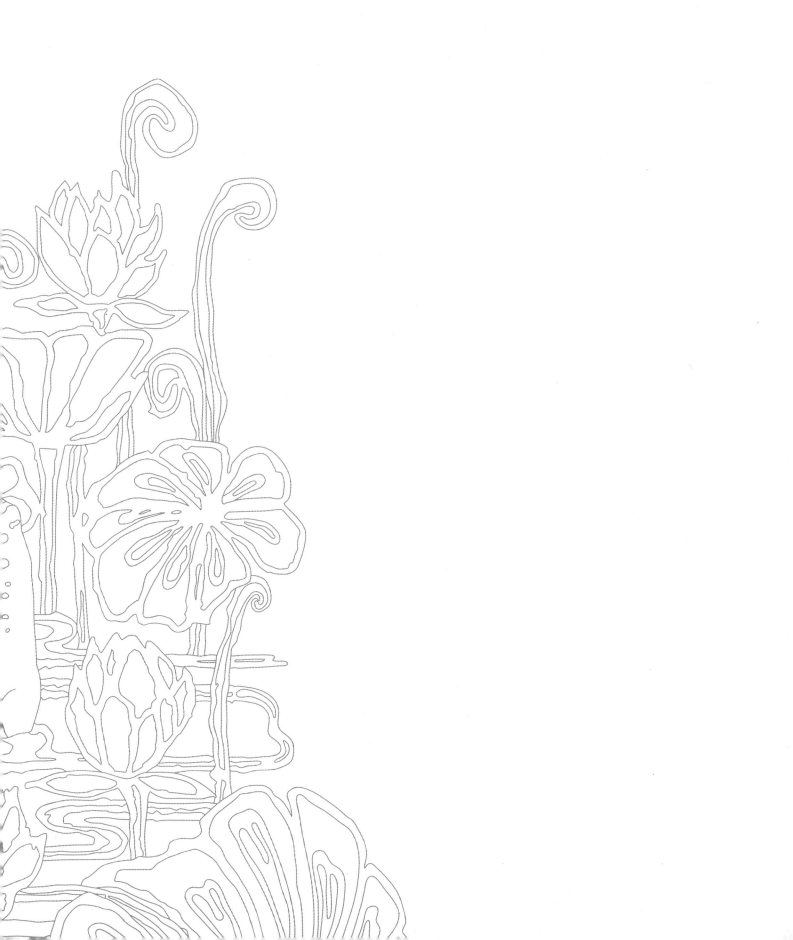

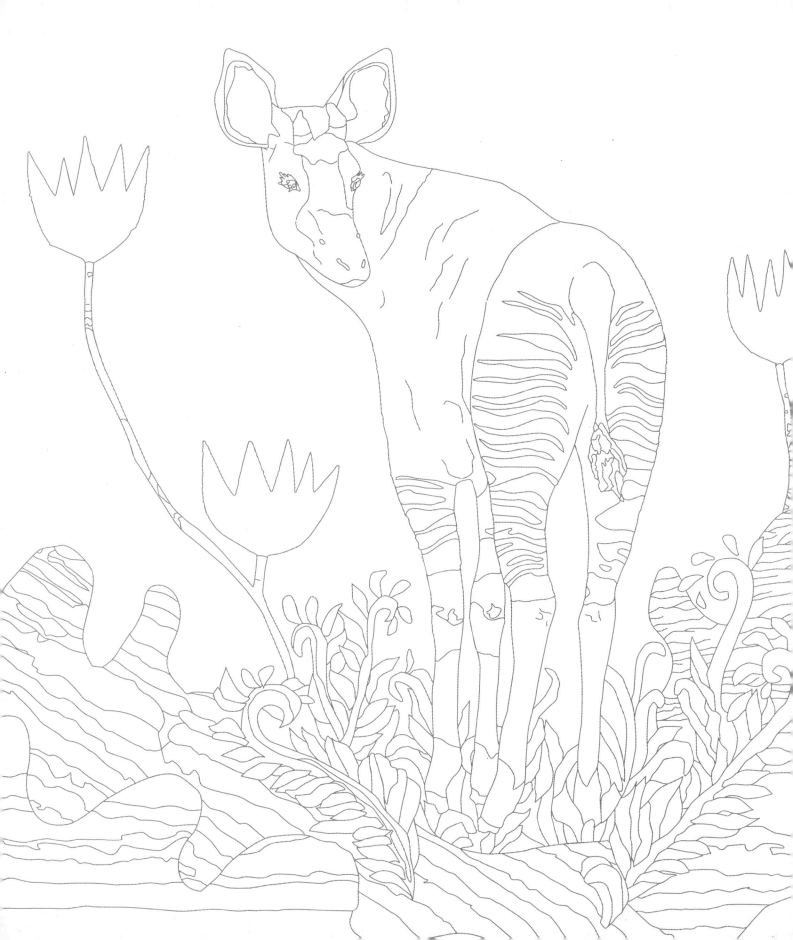

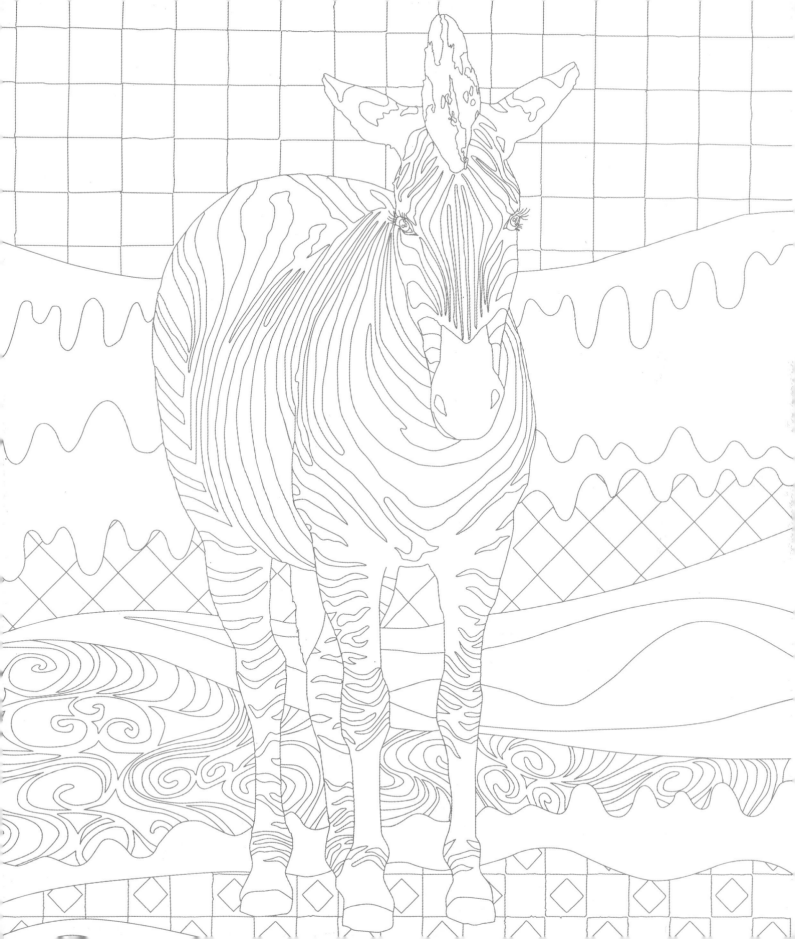

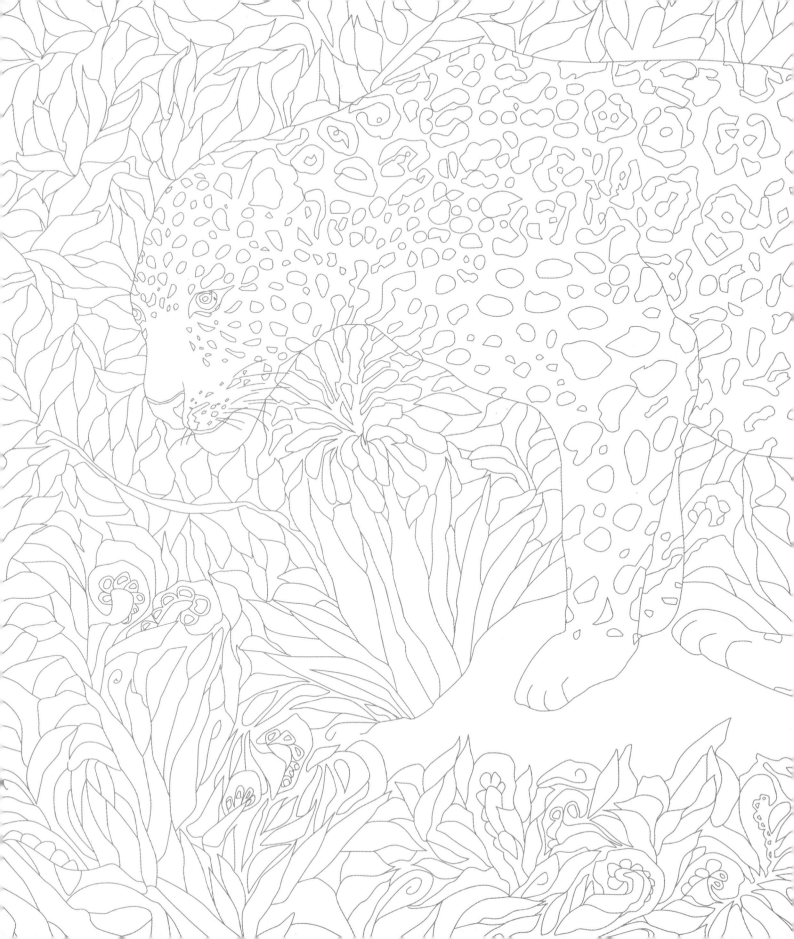

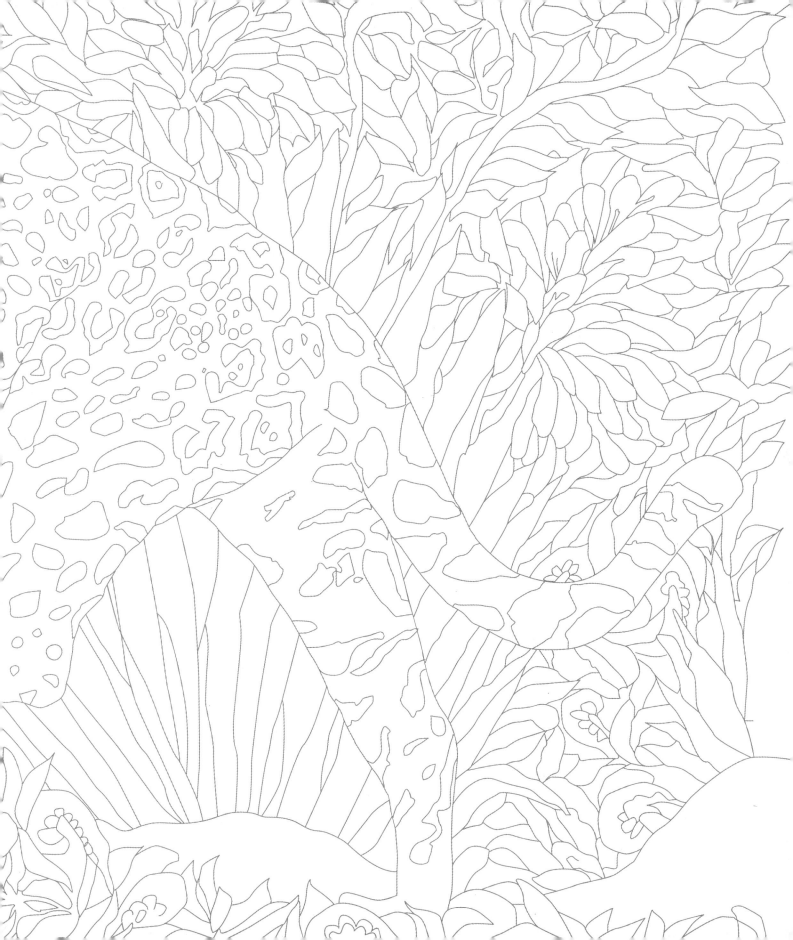

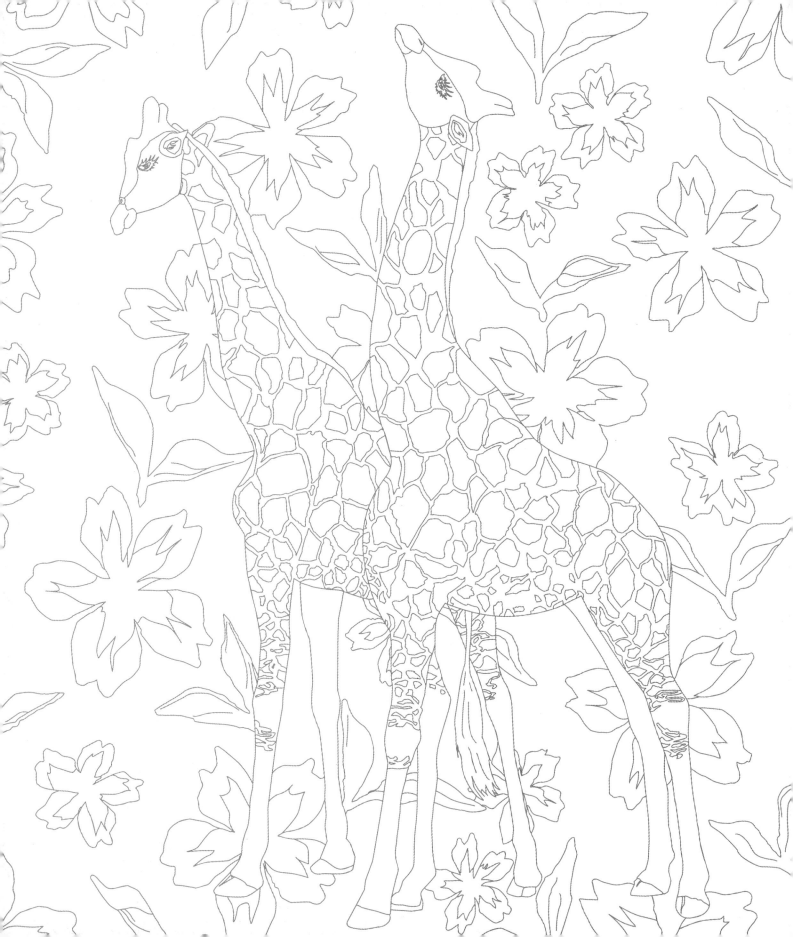

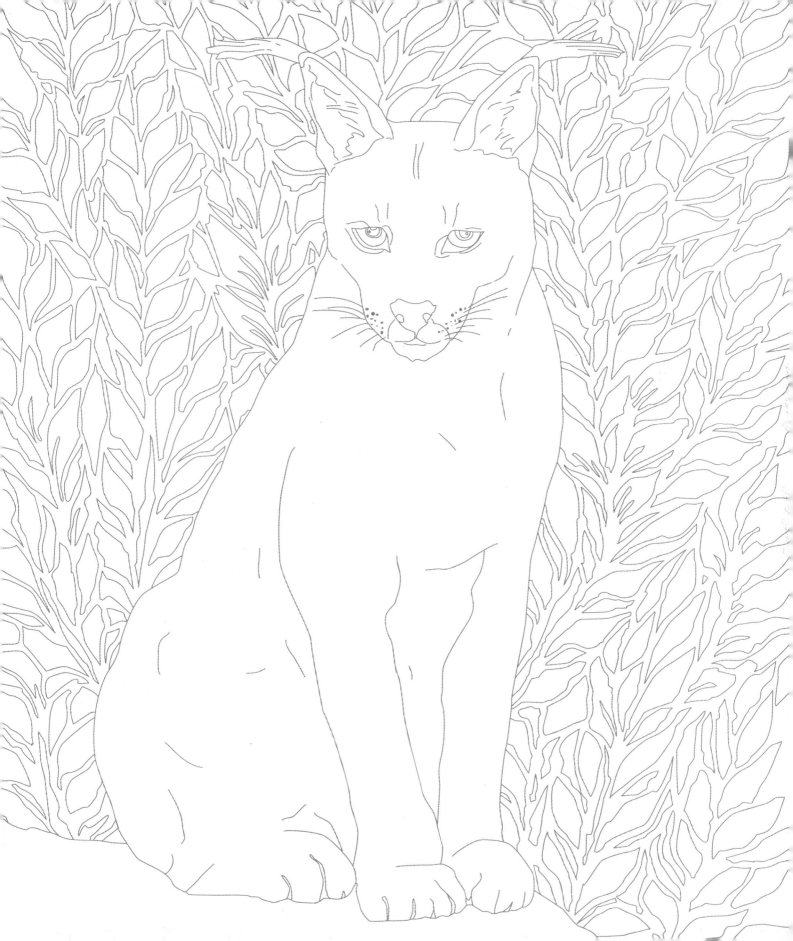

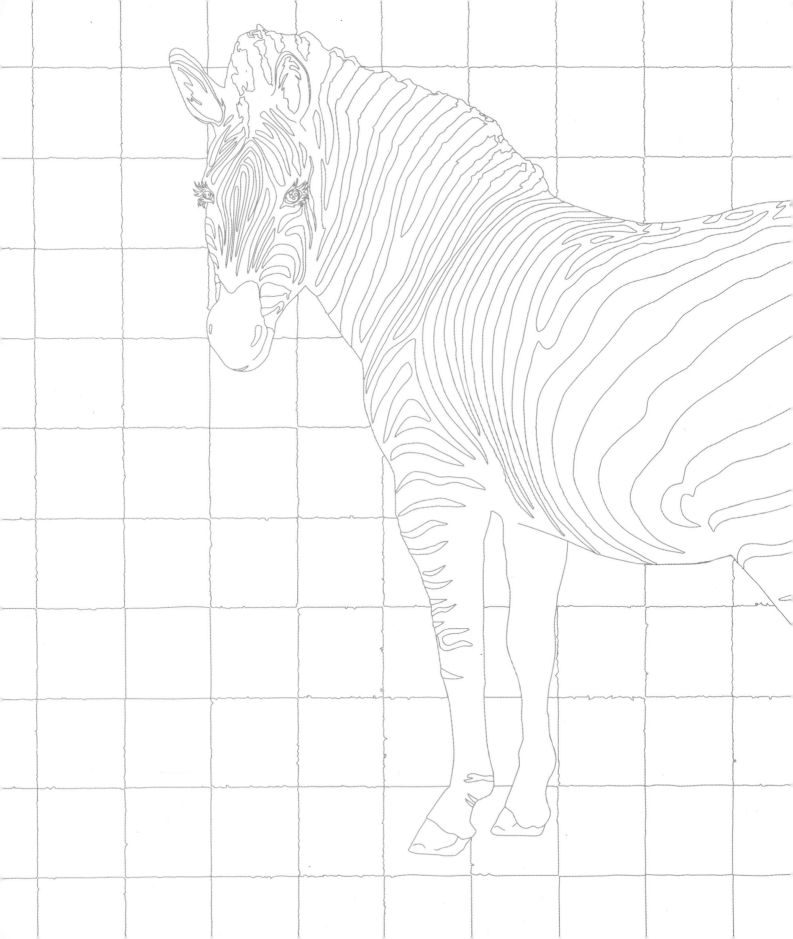

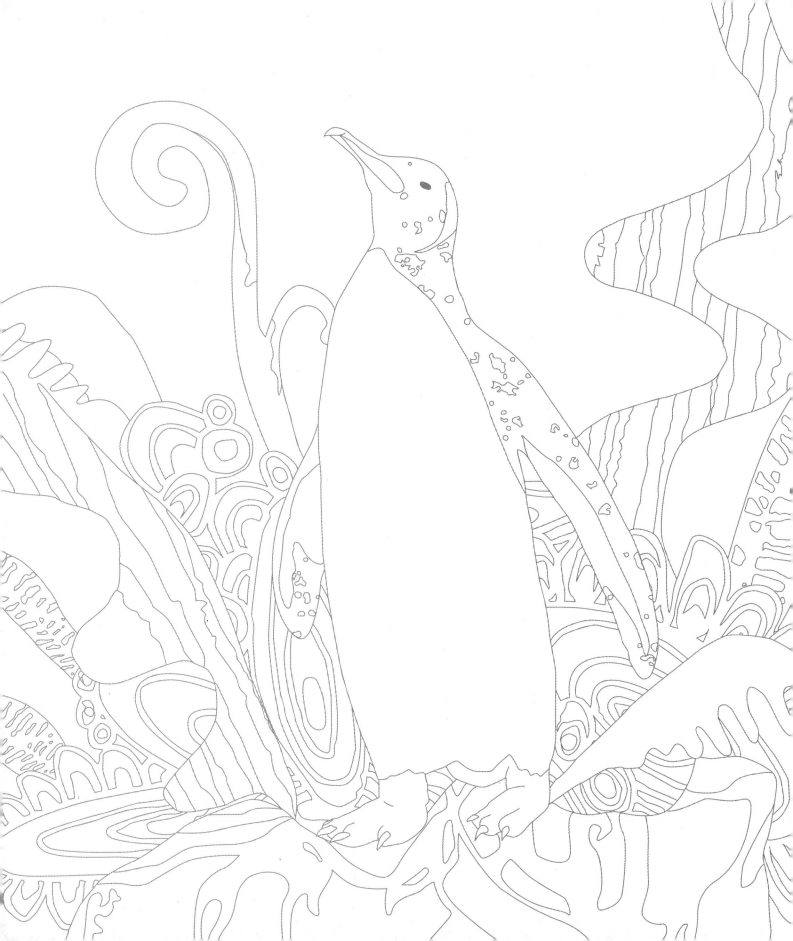

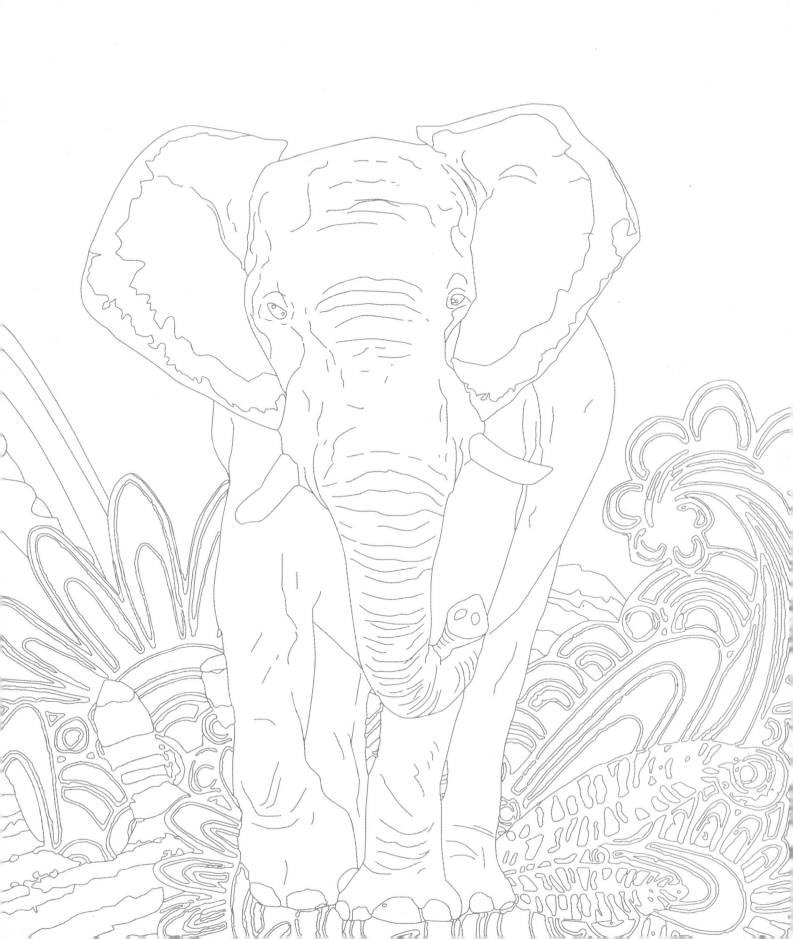

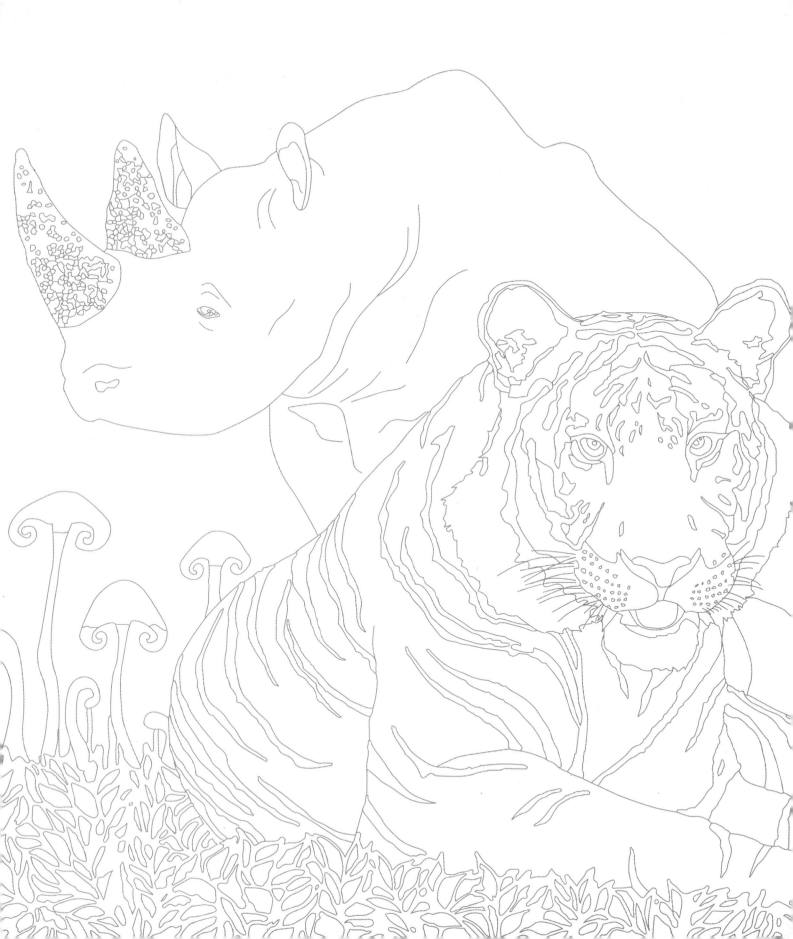

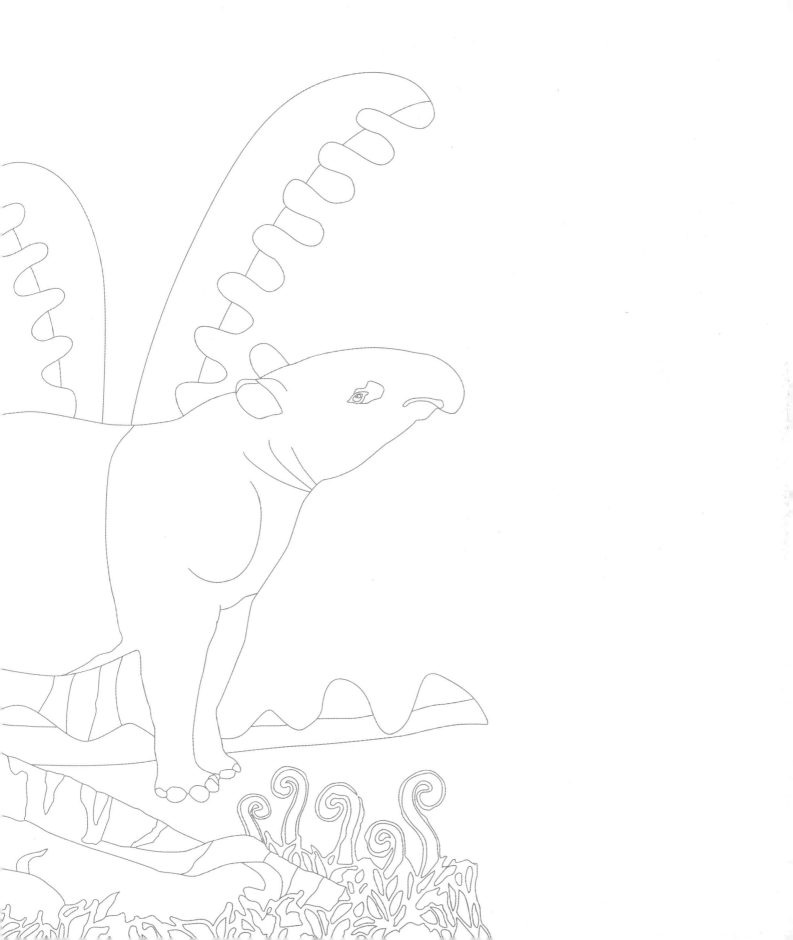

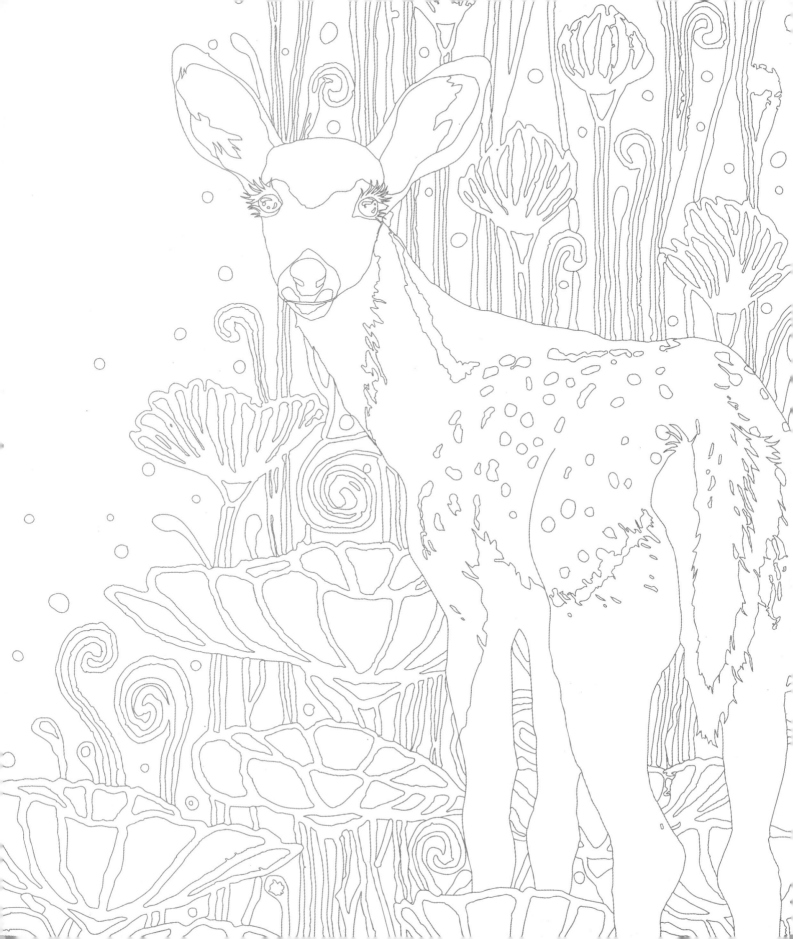

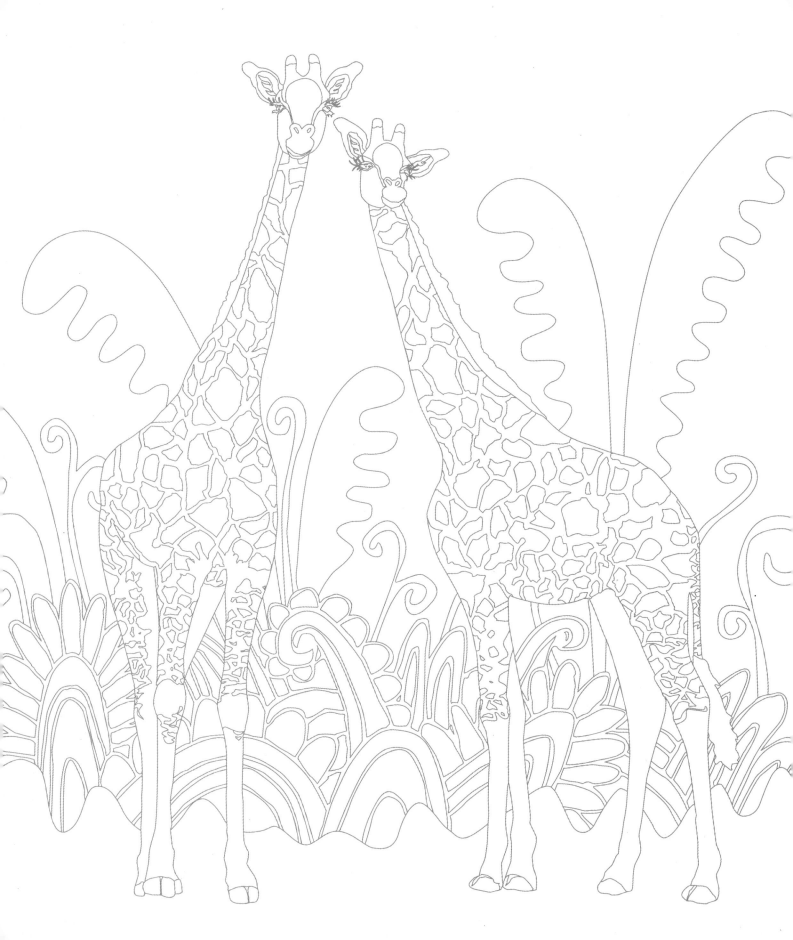

Afterword

All the drawings in this book were originally painted on canvas. We outlined the pictures and reconstructed them in as much detail as possible, based on the originals. We believe you will feel very comfortable to color them, and let your imagination fly over the uncolored space.

We did color them ourselves, and realized how enjoyable the coloring was. Through coloring them in every detail and finding new color combinations never tried before, we felt a different kind of feeling from what we get by painting.

Feel free to color them with your favorite instrument; pencils, pens, ink, watercolors or whatever.

2015 marked the 15th anniversary since we debuted as Fujiyoshi Brother's, and we are proud to publish "Fujiyoshi Brother's COLORING BOOK: Paradise of Animals" as our first coloring book. We would be more than happy if this book is loved by kids and adults alike.

Last, but not least, our foremost gratitudes go to all the staff members at GENKO-SHA, Remi-Q, Stand, and everyone involved in publishing "Fujiyoshi Brother's COLORING BOOK: Paradise of Animals."

September, 2015

Fujiyoshi
Brother's

Fujiyoshi Brother's is an art team
consisting of Taichiro & Kotaro
Fujiyoshi. They create all their works
together, which are critically acclaimed
for their vivid coloring and original
strokes. They are very active in art
events, live painting, and stage artworks.

Published in 2016 by GENKO-SHA PUBLISHING CO., LTD.

ISBN 978-4-7683-0725-0

Dobutsutachi no Rakuen by Fujiyoshi Brother's

Copyright ©2015 Fujiyoshi Brother's

First published in Japan in 2015 by GENKO-SHA PUBLISHING CO., LTD., Tokyo, Japan.

Publisher: Hiroshi Kitahara

Editor: Toshimitsu Katsuyama

Planning, art direction: Aya Akita (Remi-Q CO., LTD.)

Cover design: Stand Inc.

Photography: Isao Tanii

Distributed worldwide by NIPPAN IPS CO., LTD.

Printed in Canada